Discovery DOODLes

The Complete Series

Enjoy the book
&
happy doodling!
alicia diane durand

Alicia Diane Durand

For Lillian & Lucy

Cover Art: Robbie Short
Interior Art: Alicia Diane Durand

ISBN: 1484913639
ISBN-13: 978-1484913635

www.DiscoveryDoodles.co

"Diane knows that the Doodle is serious business. She takes even the most non-artistic reader and empowers them to think brilliantly using visual language. You don't want to miss this book."

-- Sunni Brown, co-author of *Gamestorming* and Leader of the *Doodle Revolution*

"Discovery Doodles: The Complete Series is accessible to all ages. I'm using this book to teach my nieces and nephews how to draw who are aged from 4 to 18 years old and they are all loving it. And I am applying the lessons I've learned as a Professional Trainer. The author, Diane Durand covers topics all of us should consider to have a full and rich life and this is done in an approachable manner. Not only is this a drawing book but a book for life."

-- Leenie Fabri, Graphic Recorder, Trainer & Aunt in Australia

"Starting from basic shapes through deceptively simple yet powerful diagrams, Diane Durand's "Discovery Doodles" books offer a terrific visual toolkit that can be used for all aspects of learning, working and playing. Open one of these books and pull out your pencil, pen, marker... these books will inspire you to get creative and release your inner doodler!"

- - Dean Meyers, Visual Problem-Solver and Publisher/Leader of VizWorld.com

" I can't wait to introduce Discovery Doodles to my students. Those who have thought they could never draw will have a whole new world opened to them."

-- Ruthie Mason, Teacher

Table of Contents

Who is Discovery Doodles?

Discovery Doodles is a company of artists. For over 15 years, we have traveled the world as graphic facilitators, drawing and capturing big ideas for companies of all sizes. We help them with brainstorming, product ideation, strategic plans and more.

We are on a mission to help adults and children explore their own creative space and give themselves permission to doodle, discover and dream. As a company, we have worked with hundreds of businesses, from top Fortune 500's to non-profits and start-ups, and have seen thousands of adults light up when they realize they can draw and bring their ideas to life.

Our dream is to share what we have learned about doodling and coloring in order to unlock the creativity inside all people, so we may become the Creators of Change we want to see in the world.

So many adults complain that they 'draw like a five-year old,' because that's likely when they stopped drawing. We want to encourage kids to keep drawing and get adults back to doodling. Everyone from 1 to 101 can still doodle. In fact, it is really good for the heart, mind and spirit.

Please join us and doodle!

You Can Doodle!

In this book, you will discover the wonderful world of doodling. We created this series to guide you through the basics of how to draw. We have heard thousands of people say, "I can't draw." You CAN. We believe you can and we will show you how.

Once you know the basics, there are literally hundreds of ways you can apply it from early childhood, elementary and secondary school and well into your adult life. From infancy to industry, doodling has practical and powerful applications.

Mathematicians and scientists use doodles to explain complex theories and equations. Business people use doodles to map business plans and strategies. Across the globe, people from all walks of life are doodling to help them communicate – to give visual representation and meaning to their ideas and to help others. Doodles help people innovate.

Doodling has been around forever. Just look at the cave walls and you will see people communicate using drawings. Doodling connects your hand and mind, which enhances your ability to absorb new information, process it, and remember it later. Doodling can help you unlock your hopes and dreams.

Getting Started

We created this book with you in mind and so we filled it with as many doodles as possible to inspire you to make doodles of your very own. As they say, "The picture is worth a thousand words." See?

Step-By-Step

You are invited to use this book as a guide. We will show you step-by-step all you need to know to start doodling and create Doodle Sketchbooks of your own to capture your learning, processing, discovering, understanding and dreaming.

You will need:

1. Pencil

2. Markers

3. Sketchbook or Paper

Sketchbook Basics

Basic Shapes

Doodling begins with the basic shapes of a square, triangle and circle. Next, turn them into a cube, pyramid and sphere.

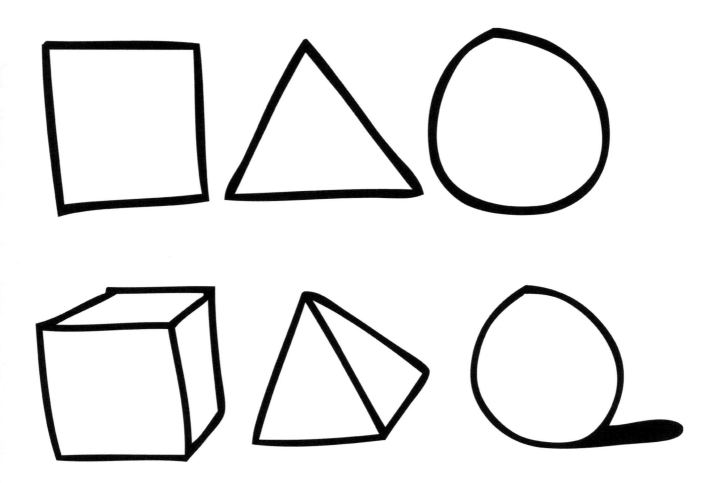

Basic Shapes Color

Color in the basic shapes and use darker colors for shading.

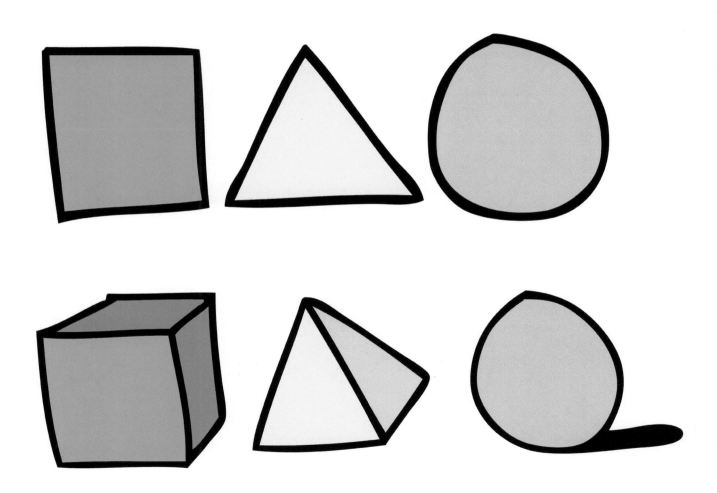

More Basic Shapes

These are a few more basic shapes you can add to your drawing vocabulary.

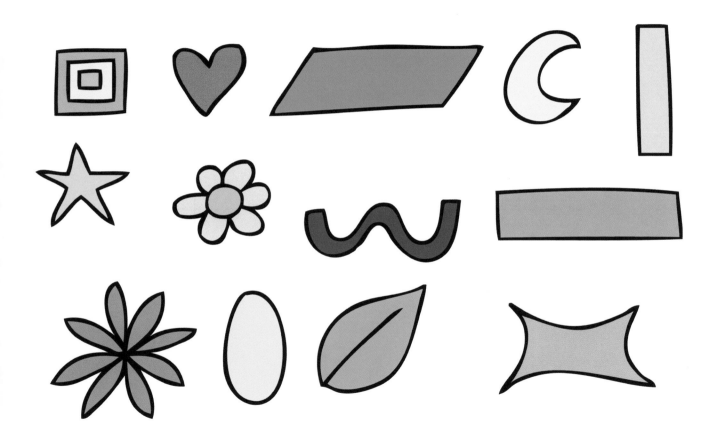

Put Shapes Together

When you start to put basic shapes together, you begin to create doodles.

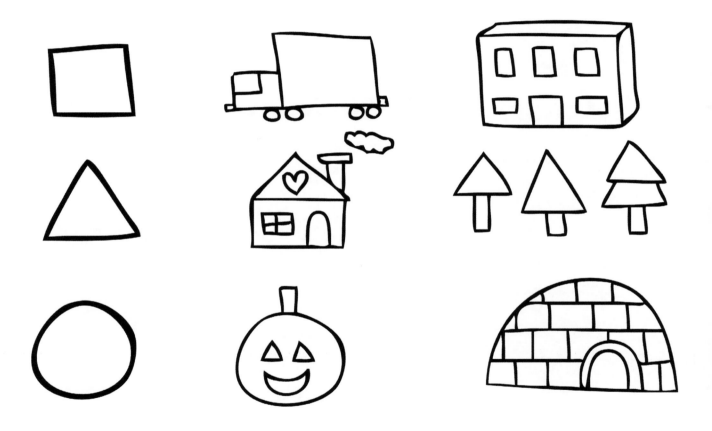

Basic Shapes Landscape

Create a landscape using circles, lines, triangles and squares.

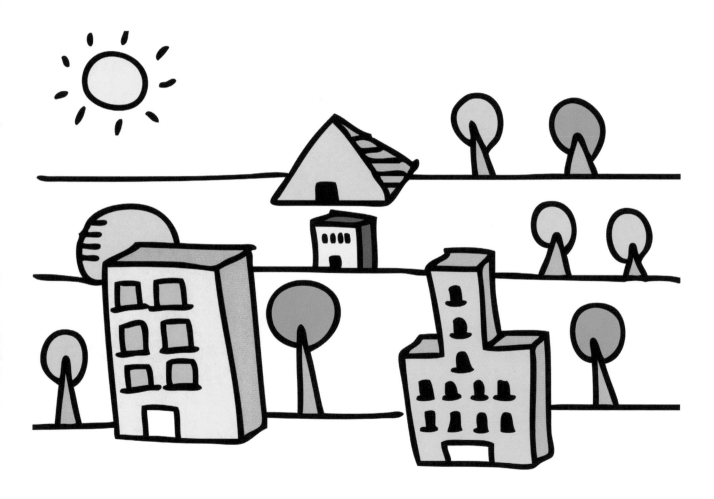

Basic Shapes Drawings

By combining all the basic shapes, you can draw anything.

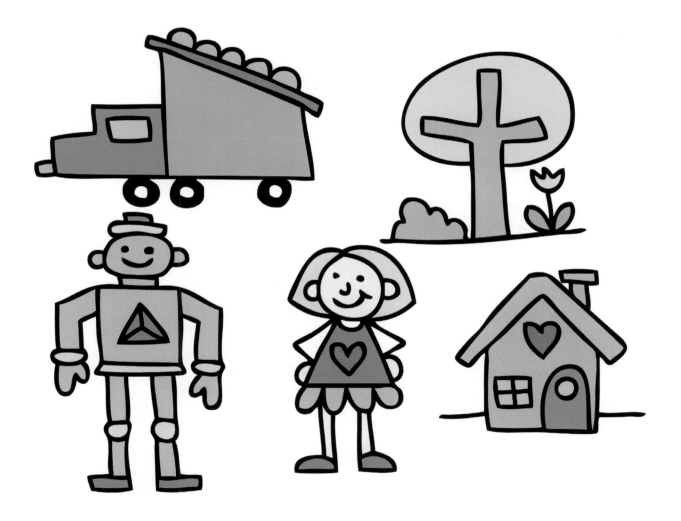

Arrows

An arrow is a combination of lines, rectangles and triangles.

Fancy Arrows

There are lots of fancy ways to draw an arrow.

Writing Letters

Letters can be written many different ways. Practice different types of fonts.

ABCDEFGHIJKLMNOPQRSTUV

ABCDEFGHIJKLMNO

abcdefg

abcdefghijk

abcdefghijklmnop

Writing Numbers

Numbers, like letters, and can be written using a variety of fonts, too.

12345678

123456789 10 11 12

1234

12345678

Borders, Patterns & Frames

Borders, patterns and frames add interest to your doodles.

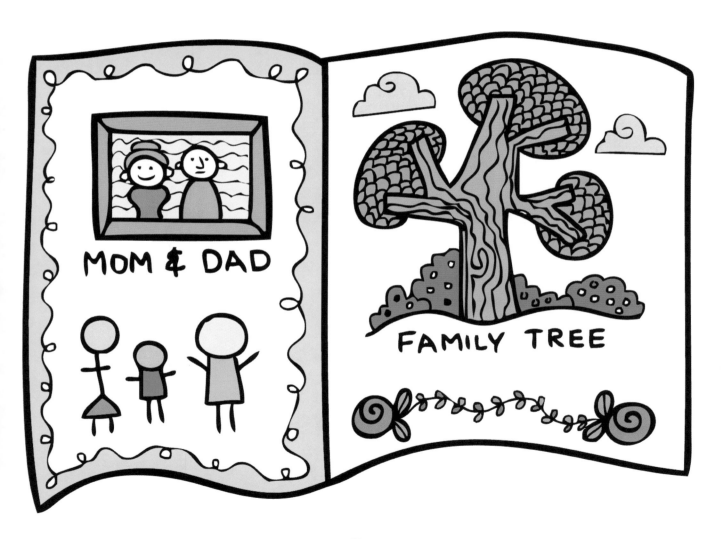

Borders

Borders are made using swirls, zig zags, leaves, hearts and more.

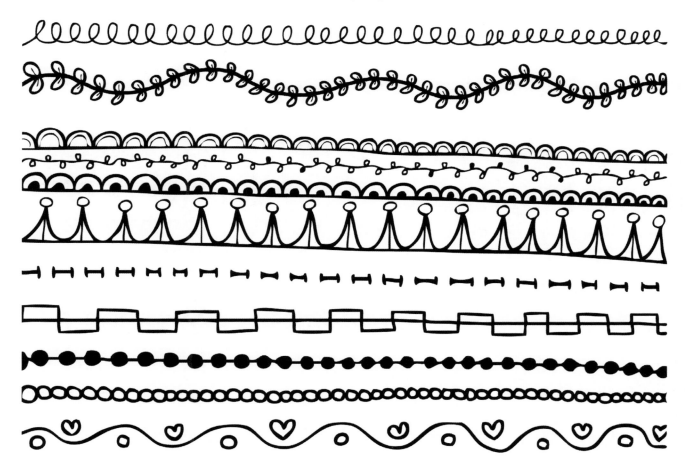

Patterns

Patterns are created by repeating basic shapes.

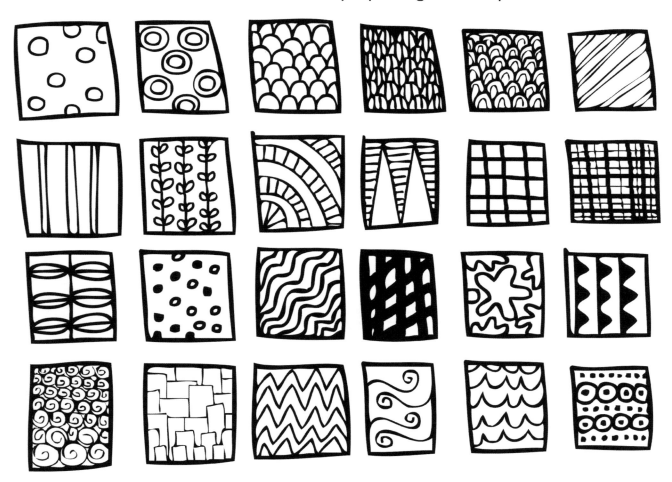

Frames

Frames are great for adding structure to your doodles.

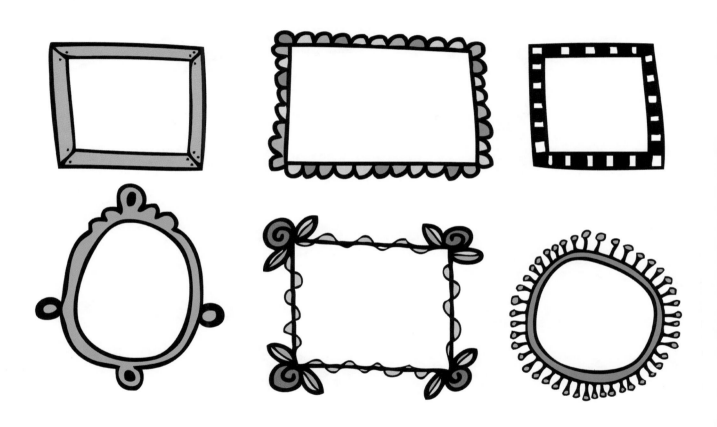

Drawing Faces

These are all the elements you need to make faces.

Emotions

Mix together the basic face elements and create all kinds of faces.

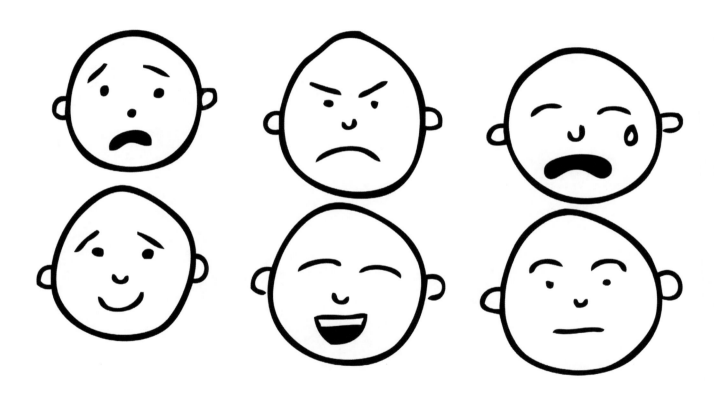

Hair

Using some of your basic shapes, add hair to your people.

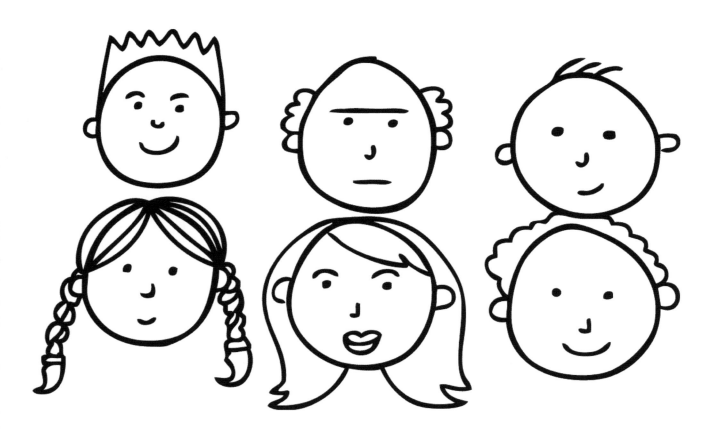

Personality

Once you have a face and hair, add some personality to your people.

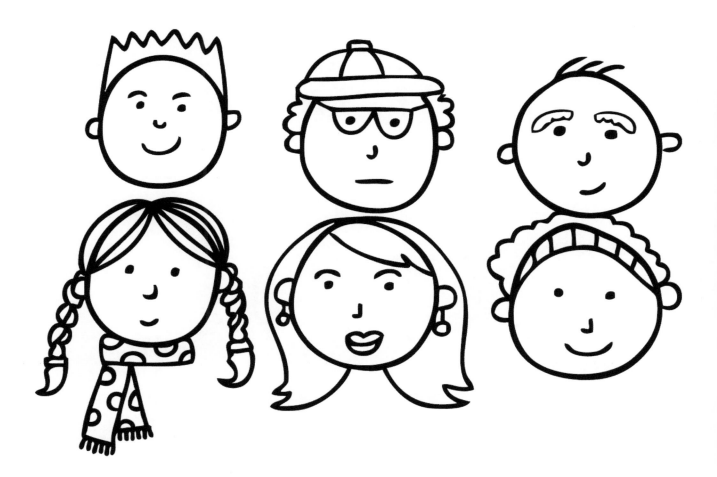

People

Drawing people is very fun and easy. You can do it with four simple steps.

1. Start with a circle.

2. Add a line.

3. Part of a triangle for the legs.

4. A line for the arms.

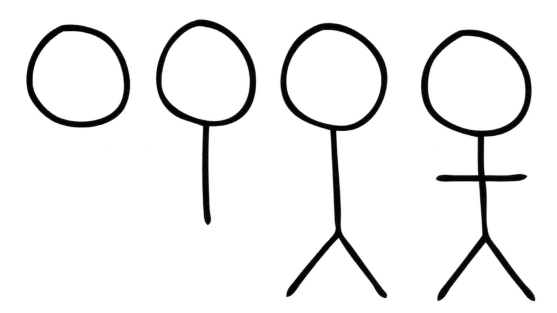

Ice Cream People

With Ice Cream People, simply add a triangle for the body and some half-circle feet.

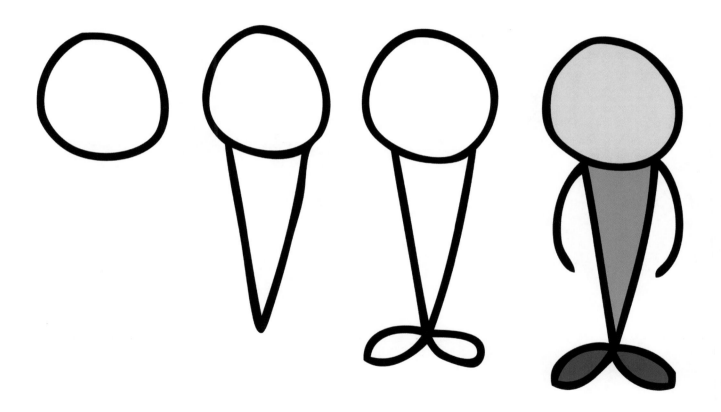

Bean People

Now you are ready for Bean People. Add some fun details and color.

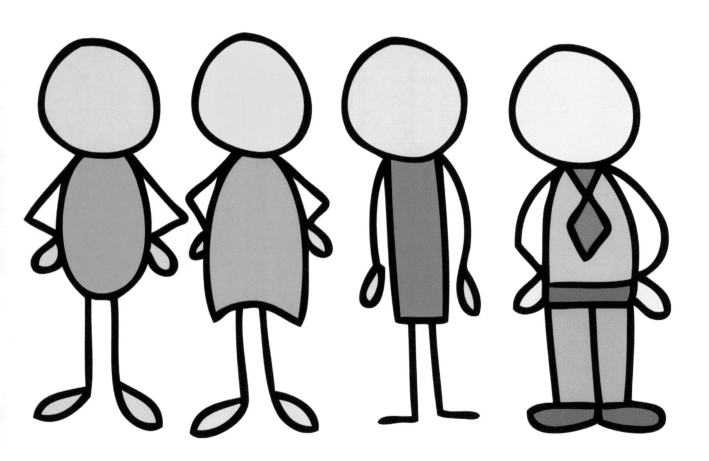

Lots of People

Once you know how to draw these simple people, the possibilities are limitless.

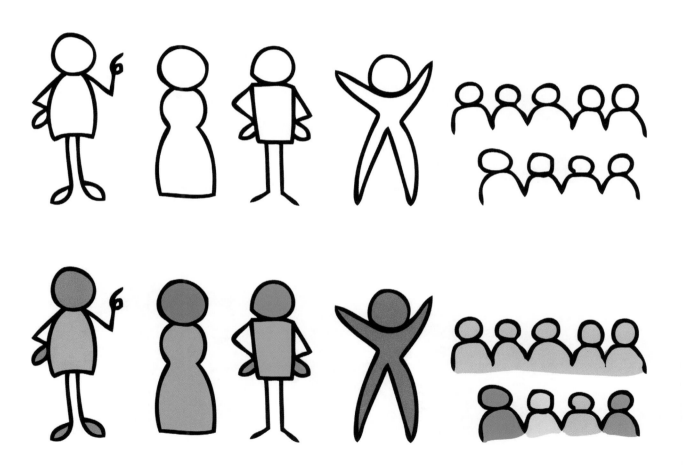

The Color Wheel

The color wheel illustrates all the color relationships.

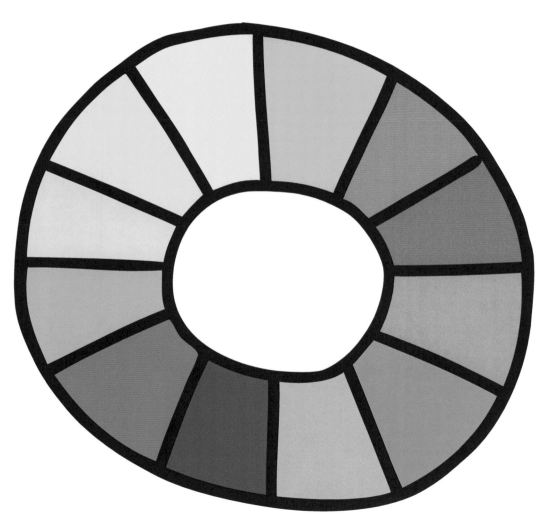

Primary Colors

A primary color is a color that you cannot create by mixing colors.

Secondary Colors

A secondary color is made when you mix two primary colors together.

Tertiary Colors

A tertiary color is made when you mix a primary and secondary color together.

Color Feelings

You can use colors to add fun and feelings to your drawings.

Color Spectrum

When the colors are organized like a rainbow, we call it a color spectrum..

Color Spectrum Variations

Look at how the same colors change with different backgrounds.

Early Childhood

Kids Drawing Stages

Children develop creativity through drawing. As soon as children can hold a pencil, marker or crayon, they can draw. There are four stages of development when learning to draw:

	The Scribbling Stage – 1 ½ Years Old It all begins with a scribble. Children begin by simply making contact and drawing marks on the page. These scribbles quickly begin to change into definite shapes. It is very natural for children to make circular movements anatomically.
	The Pre-Schematic Stage – 3 Years Old The first drawings provide a tangible record of the child's conscious and thinking process. They typically start by drawing a person. A circle for head and two vertical lines for legs. These drawings later become more developed and complex.
	The Stage of Symbols – 4 Years Old From tiny scribbles, they make a leap into discovering the wonderful world of art. They can draw something that represents the world around them. They begin to create a family, a cat, a tree, and more. They will begin to draw their observations of their environment.
	Pictures That Tell Stories – 5 Years Old The child can now tell stories with their drawings. They can also work out problems. This helps them process and understand their surroundings. Once the child can express a problem, they can cope with the feelings they experience.

Kids Love to Draw

Drawing is especially fun for children because they can do it independently. The can create something from their imagination and make it come to life on paper, which opens a whole new world of possibility for the developing mind.

Learning Styles

There are many ways that children and adults learn new information.

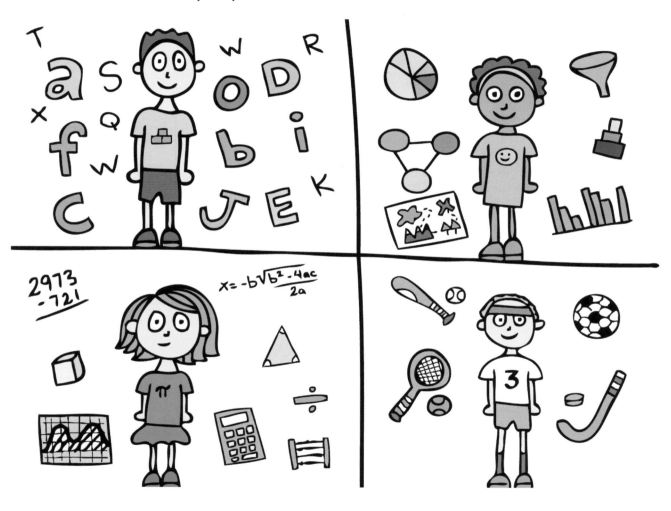

Learning Styles

Do you learn through movement, music, modeling, meditation, meaning or math?

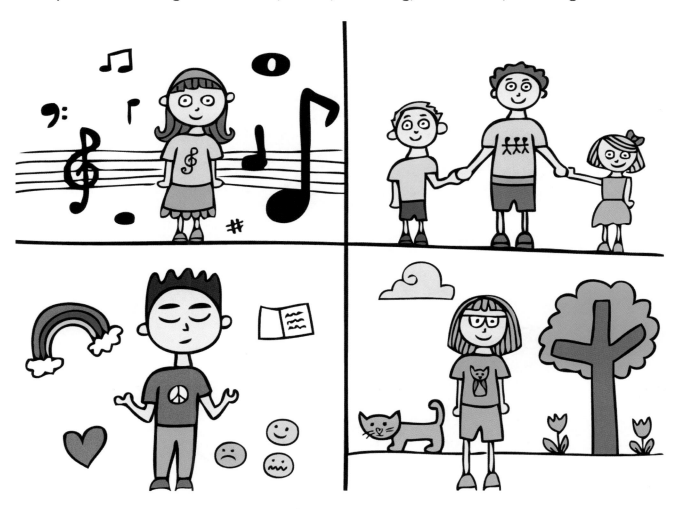

You

It is always fun to begin by drawing yourself. What is unique about you?

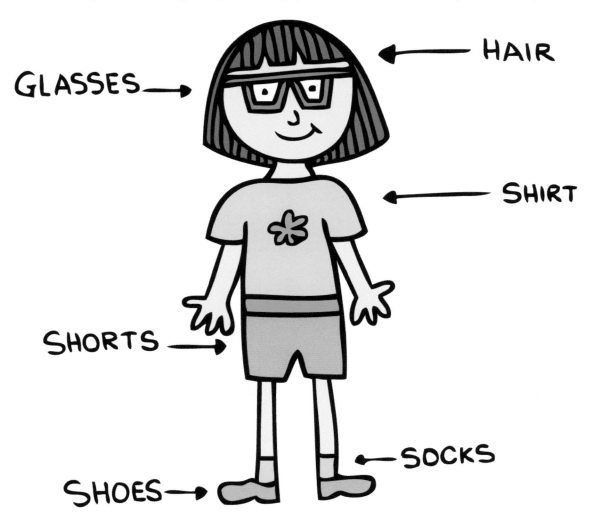

GLASSES →

HAIR ←

SHIRT ←

SHORTS →

SOCKS ←

SHOES →

Clothes

A fun activity is to draw different outfits on a clothesline.

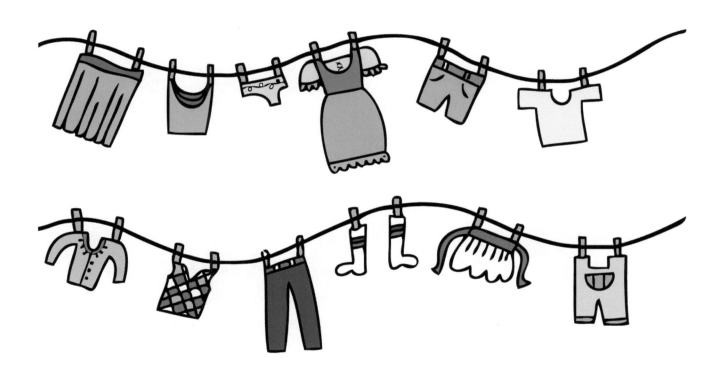

Your Family

Create a drawing of your family. Do you have a big or small family?

Family Tree

Have fun together creating a drawing of your extended family tree.

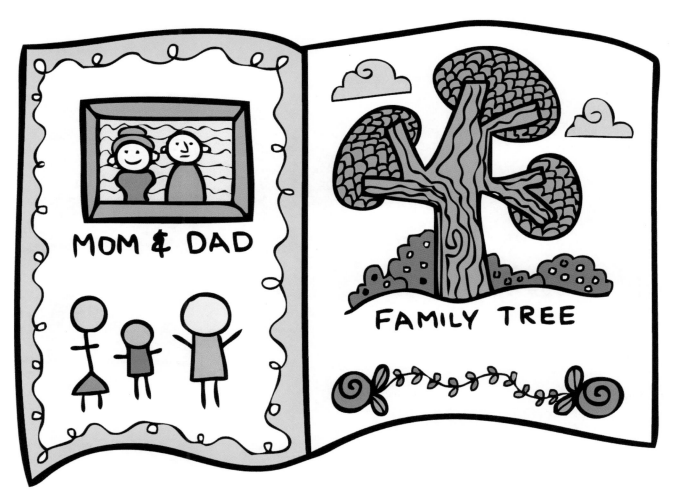

Your Home

A great activity is to doodle your home. Do you live in the city or country?

Inside Your Home

Now make a drawing of inside your home.

Your Neighborhood

Can you draw a picture of your neighborhood?

Your Community

Build a map of your community.

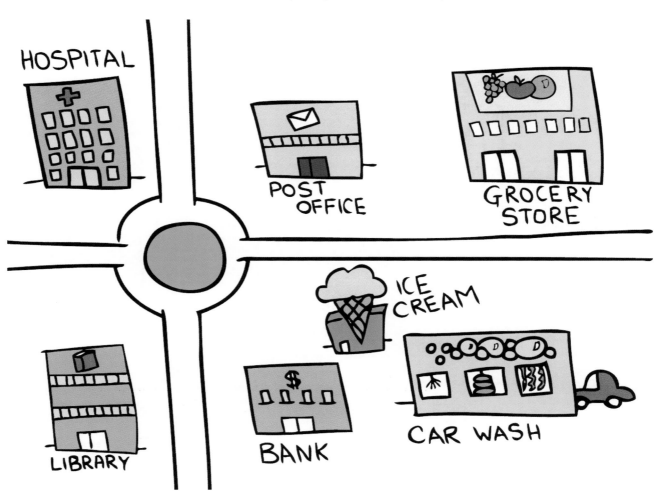

Your School

Create a drawing of your school.

Your Playground

Can you draw your playground?

Your Classroom

What do you love about your classroom? Do you have activity centers?

Classroom Centers

Fun signs can be drawn to represent different centers in the classroom.

School Play

Make signs to promote and announce your school play. You can also create signs for the different acts.

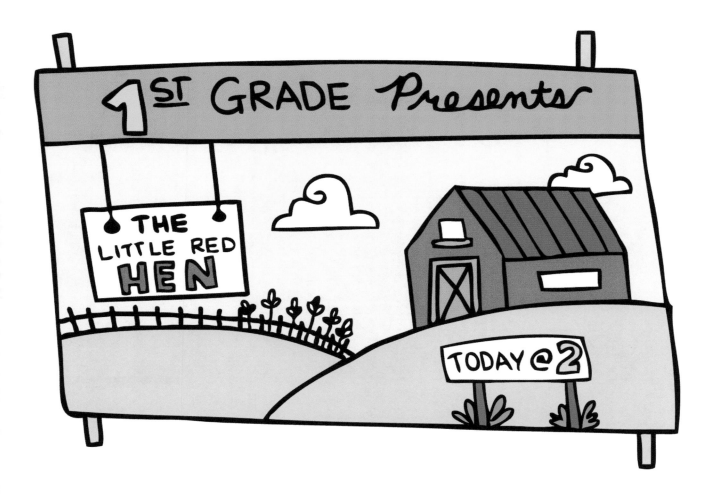

Days of the Week

Create a calendar for yourself with all your family activities.

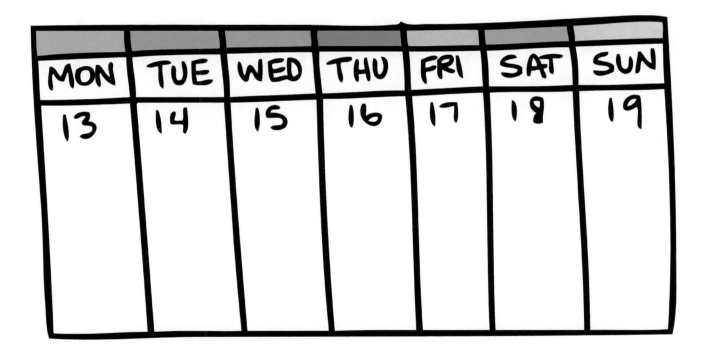

MON	TUE	WED	THU	FRI	SAT	SUN
13	14	15	16	17	18	19

Months of the Year

What are some of your favorite things about each month?

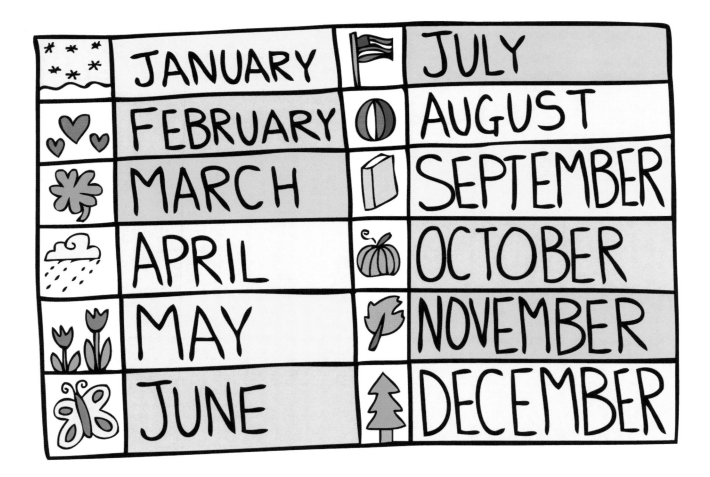

Weather

The weather is always changing. Can you draw a windy day?

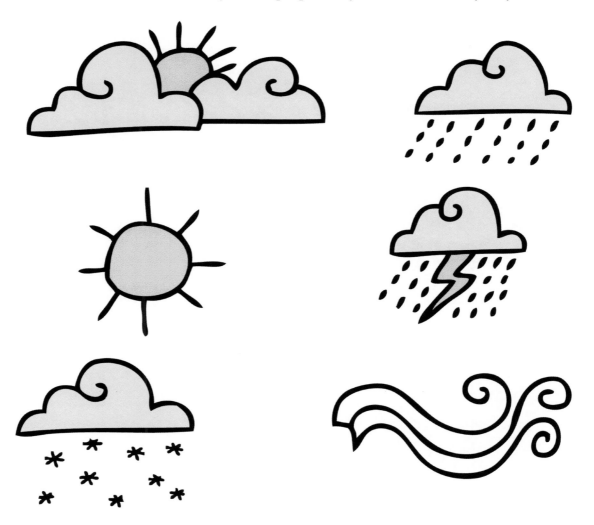

Seasons

The weather changes with the seasons. What is your favorite season?

Home Routine Chart

Use pictures and words to outline regular activities.

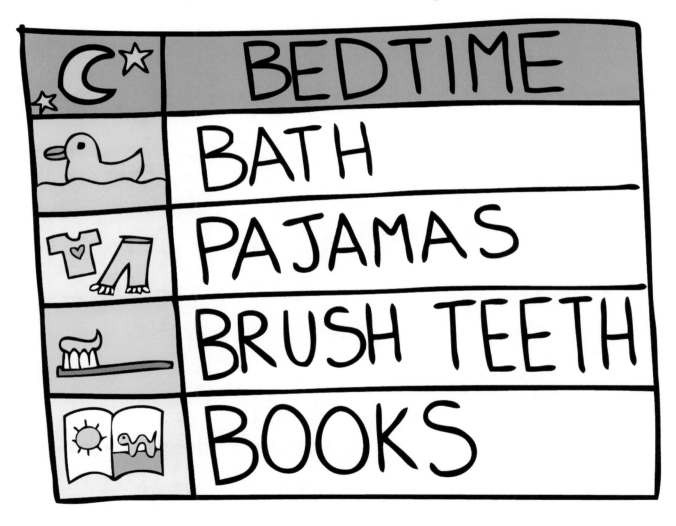

	BEDTIME
	BATH
	PAJAMAS
	BRUSH TEETH
	BOOKS

School Routine Chart

Use pictures and words to outline your routine at school.

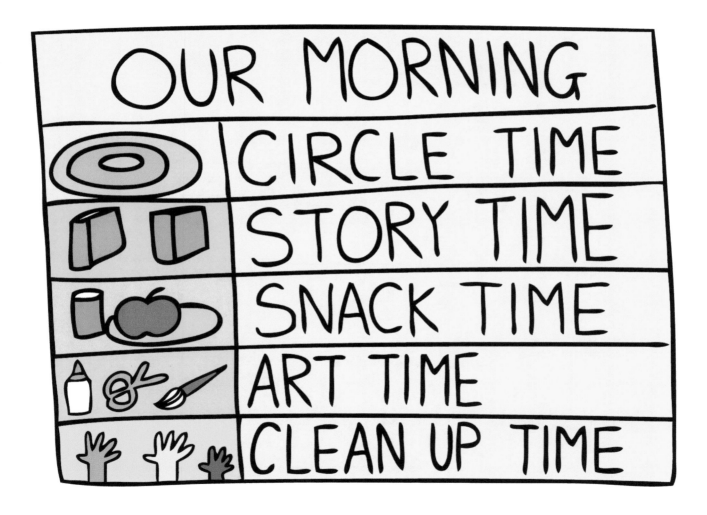

Picture Cards

Make picture cards to use for learning time or to help organize your day.

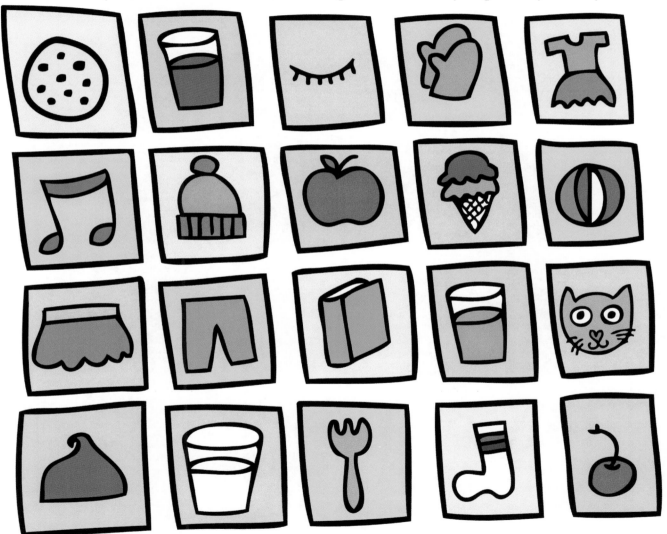

Colors

The rainbow has every color. What is your favorite color?

Holidays

These are a few common images for popular holidays.

Birthday Cake

Design a birthday cake for someone you love.

Tooth Fairy

Use your imagination to draw a picture of the tooth fairy.

Friends

Who are your friends at home and at school?

Around the World

The World

The world is so big. Make a drawing of all the places you want to travel.

Map

A map is an example of a drawing you use to navigate a new place.

Travel Journal

When exploring somewhere new, a travel journal is a way to capture your adventures.

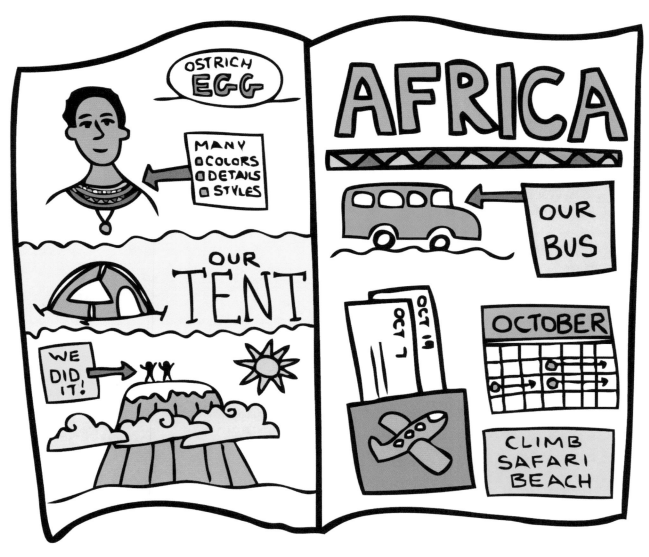

Postcards

Drawing handmade post cards is a fun way to share your experiences.

Travel by Air

There are lots of ways you can travel. What is your favorite type of transportation?

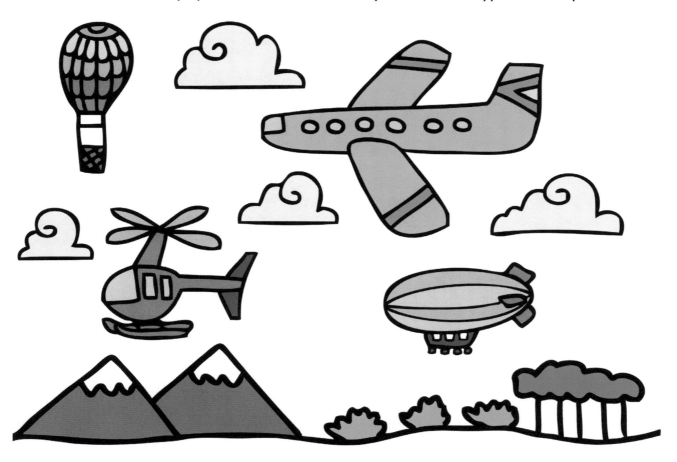

Travel by Land

Draw your favorite vehicle.

Travel by Sea

What kind of boat would you like to go on an adventure in?

Travel by Sea

What other vessels could you take for a ride?

Travel Signs

When traveling there are lots of common travel signs to help you find your way.

Traffic Signs

There are also some basic traffic signs that help keep you safe.

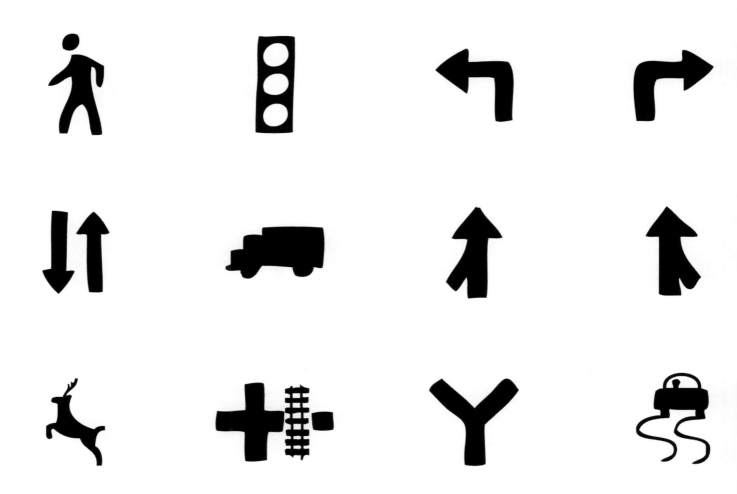

Hobo Signs

Did you know during The Great Depression there was an entire visual language created?

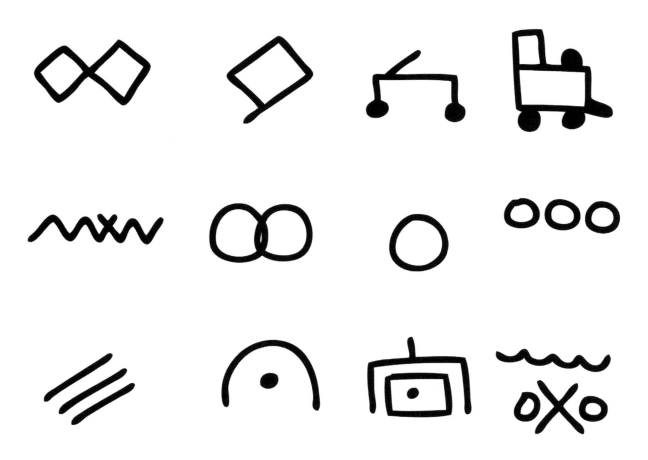

Hobo Signs

These drawings were used to explain how to get food, medical attention or locate the closest train.

Petroglyphs

From our earliest days, man has painted or etched symbols on cave walls.

Petroglyphs

What do you think these symbols mean? Can you make up your own?

Online Icons

A visual vocabulary made of simple icons helps us navigate the internet.

Online Icons

What do you think these symbols mean? Can you make up your own?

Hieroglyphics

Egyptians used a set series of icons and images to share stories.
What do you think this story is about?

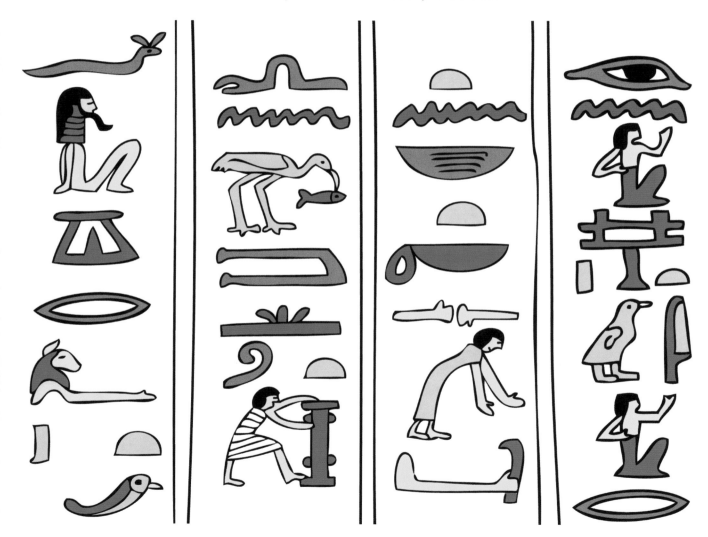

Constellations

From the early days, people saw drawings in the stars to create the constellations.

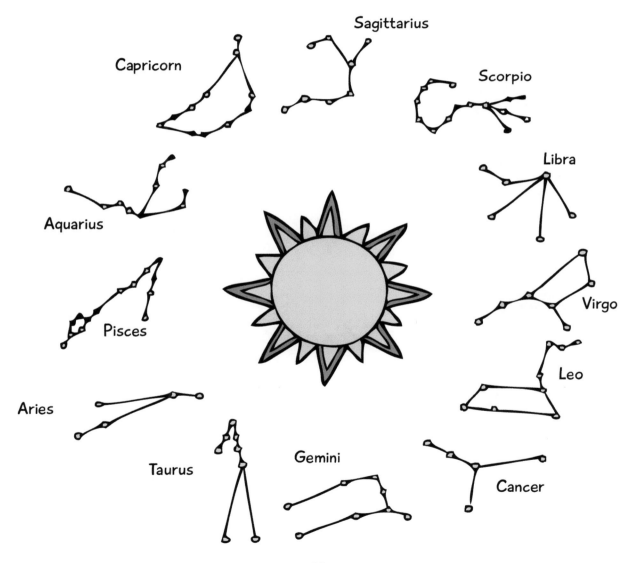

Zodiac Signs

The zodiac contains twelve icons to represent the time of year a person is born.

Zodiac Signs

People believe that the night stars influence your personality and temperament.

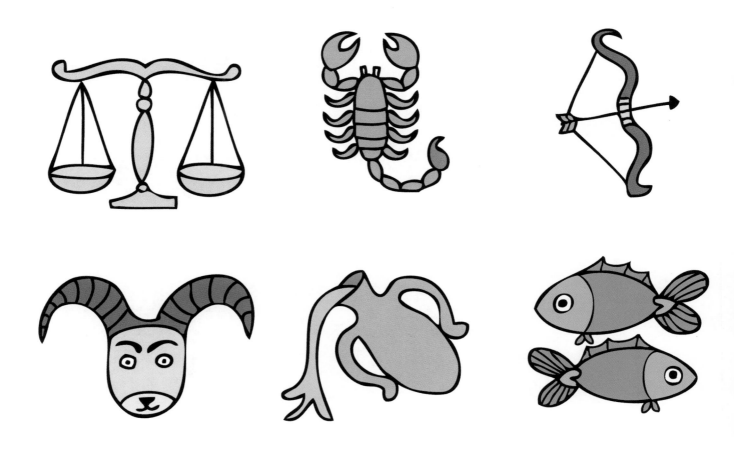

Yantra

A Yantra is a visual symbol used for meditation and reflection.
Can you make one for yourself? What shapes would you use?

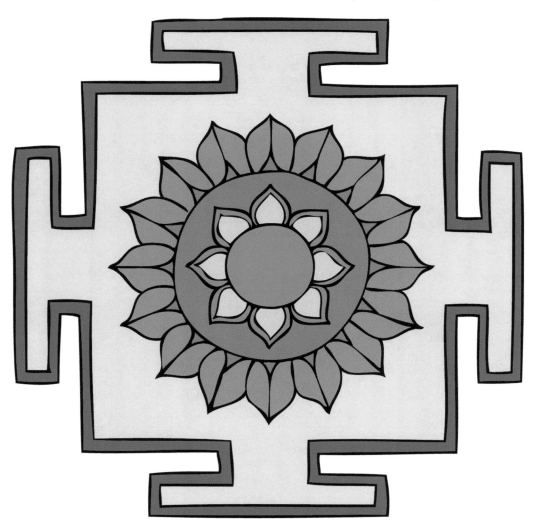

Math & Science

Geometry

If you like math and drawing, then you will love geometry
which is playing with shapes and their properties.

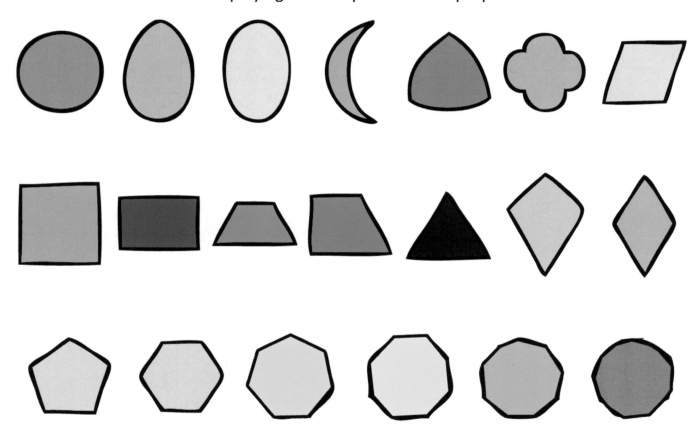

Triangles

Triangles come in three basic shapes - equilateral, isosceles and scalene.

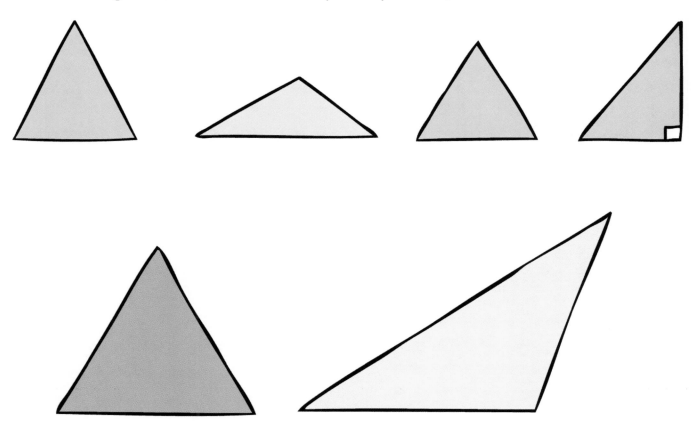

Dimensions

You can add depth to an object for more dimension..

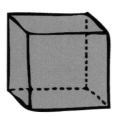

Fractions

You can understand fractions more easily by using a sketch to show the full relationship.

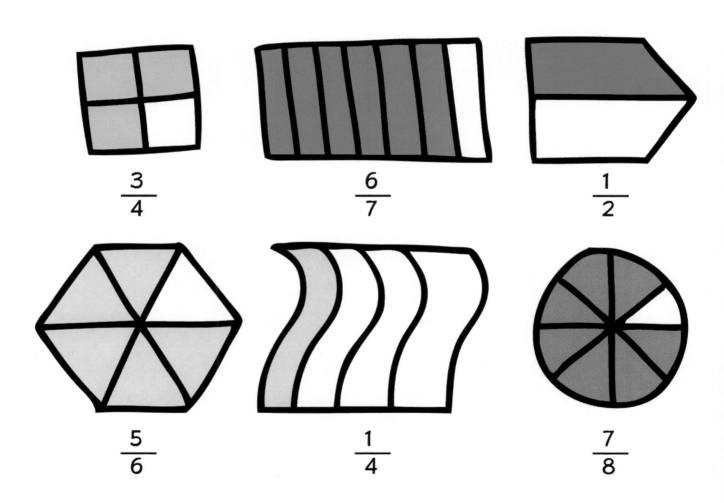

$$\frac{3}{4}$$

$$\frac{6}{7}$$

$$\frac{1}{2}$$

$$\frac{5}{6}$$

$$\frac{1}{4}$$

$$\frac{7}{8}$$

Math Symbols

Even math is rich with doodling. Look at all the types of symbols used to explain mathematical operations.

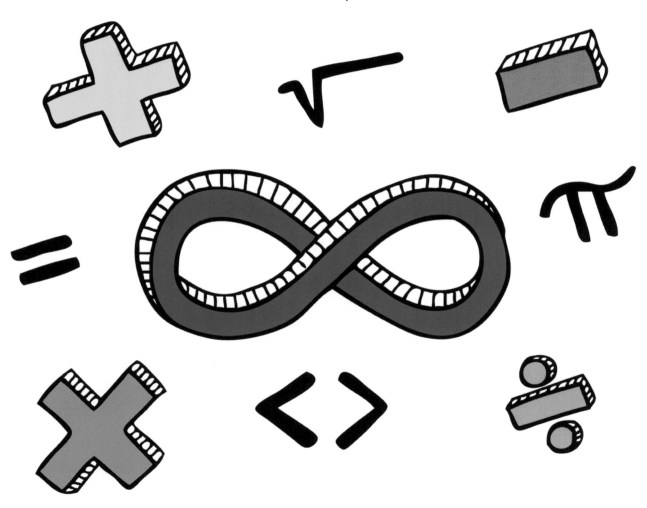

Word Problems

Use a quick sketch to make a word problem visual.

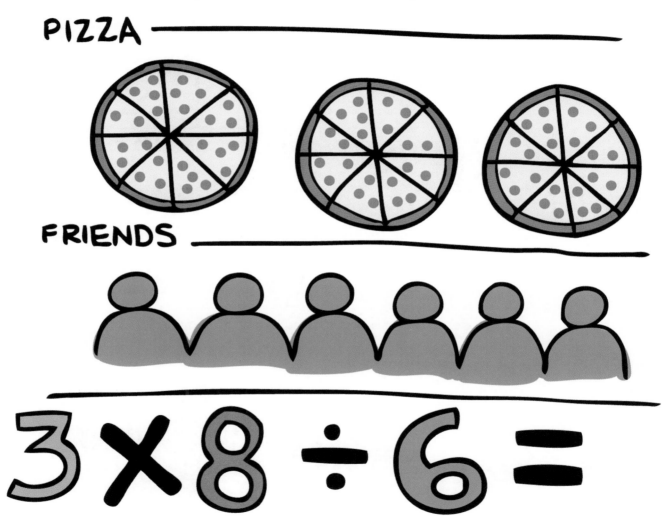

PIZZA

FRIENDS

$$3 \times 8 \div 6 =$$

Formulas

Mathematical formulas are doodles that show the logic of a problem.

$$L = AP^2$$

$$L = \sqrt{\frac{\sum (P - \bar{P})^2}{A - 1}}$$

$$L = \frac{\log A}{\log B}$$

$$P = \frac{A!}{(A-L)!}$$

$$E = mc^2$$

$$A = \sum_{i=1}^{n} \frac{(L-P)^2}{P}$$

$$A^2 + P^2 = L^2$$

$$a^2 + b^2 = c^2$$

$$A = A_0 \left(1 + \frac{L}{P}\right)^{PL}$$

$$V = IR$$

Graphs

Graphs are visual representations of mathematical solutions.

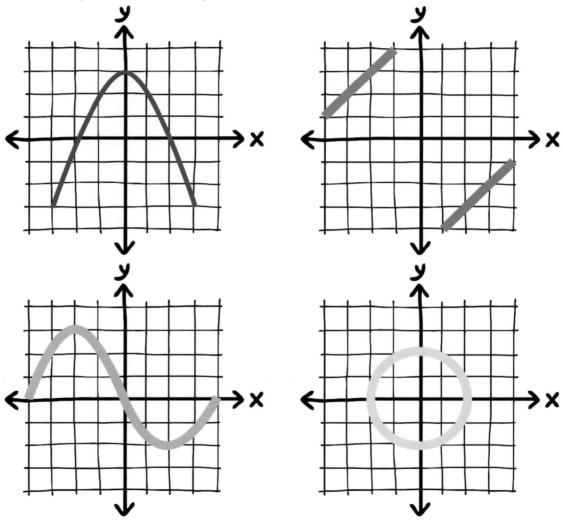

Science Lab

You can draw your science lab to remember where things belong.

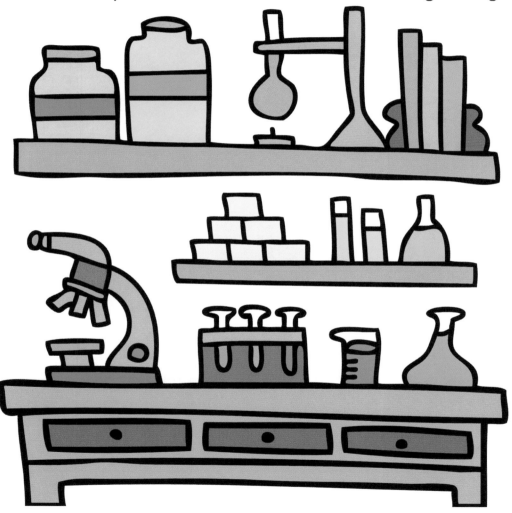

Science Safety

Safety is very important especially, in your science lab.

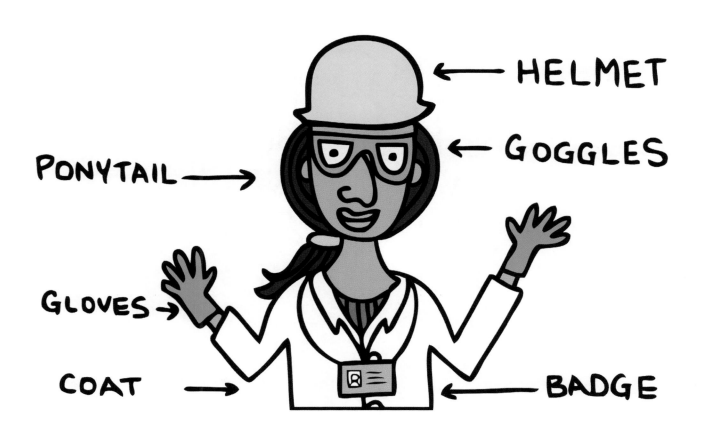

Dissection

By drawing a dissection, you can illustrate what you have uncovered in the process.

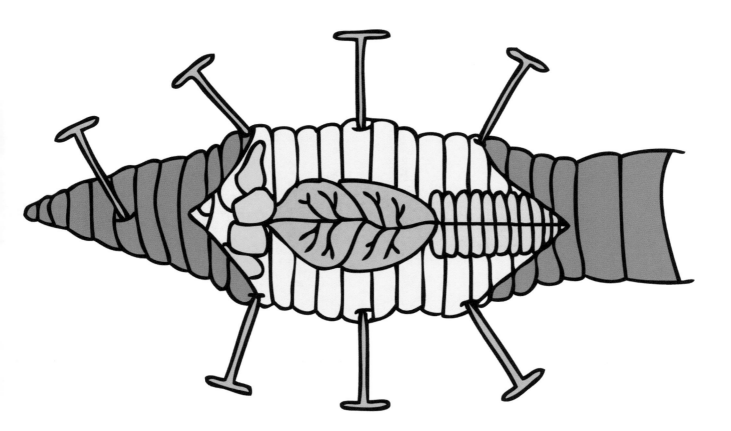

Anatomical Drawing

Anatomical drawings can be used when studying organisms and organs.

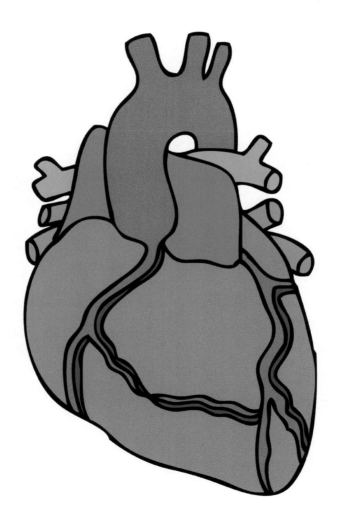

Fossil Fuels

Create a drawing showing the layers of earth covering fossil fuels.

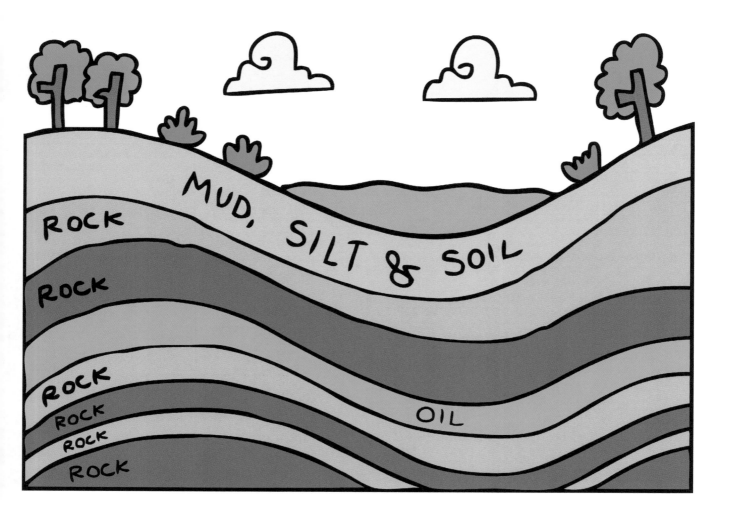

Rock Model

You can show the differences between sedimentary, igneous and metamorphic rock.

The Water Cycle

Make a drawing to show how the sun evaporates water, snow and rain.

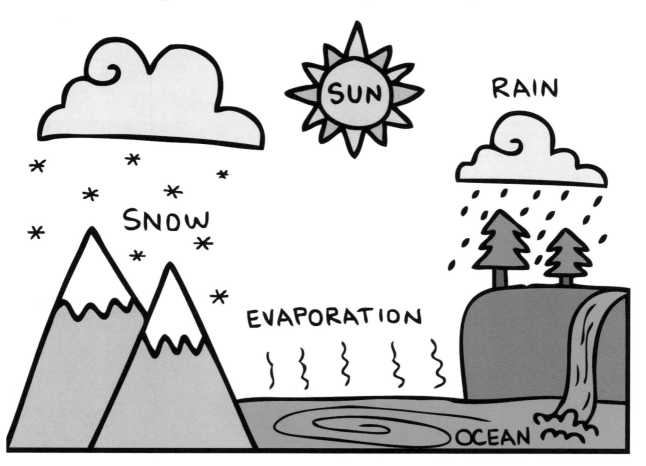

Life Cycle

All life goes through different stages of development.

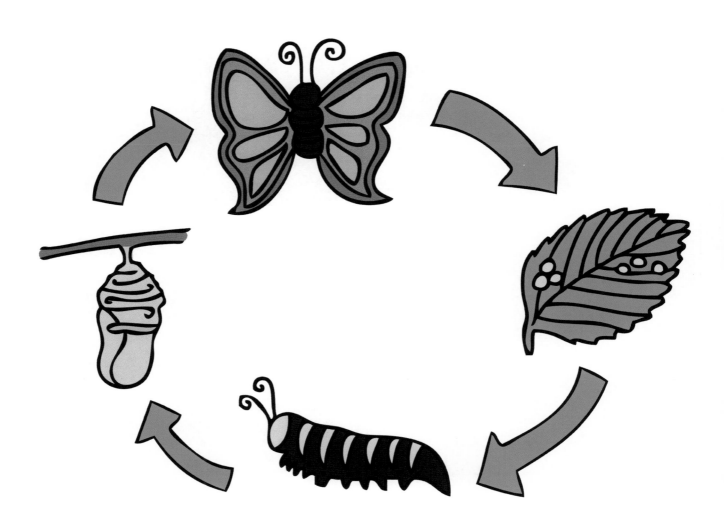

Habitats

A habitat is the natural environment of a particular animal, plant or organism.

Habitats

Can you make a drawing of an animal and their habitat?

Types of Energy

This model represents different types of energy.
It includes solar, wind, geothermal, ocean, hydropower, biomass and hydrogen.

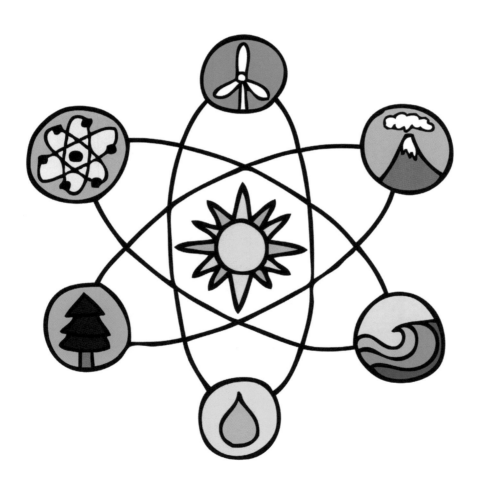

Double Helix

The Double Helix represent the DNA code of instructions for living organisms.

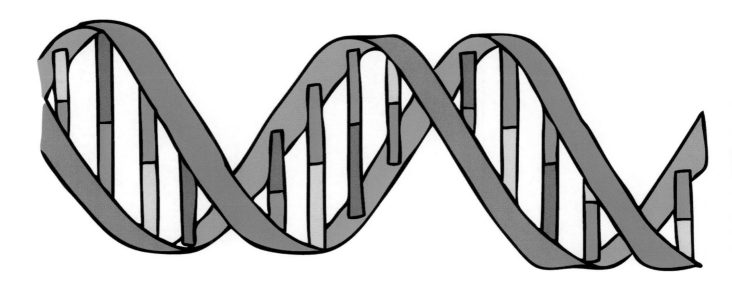

Vertebrates

These are animals with a backbone.

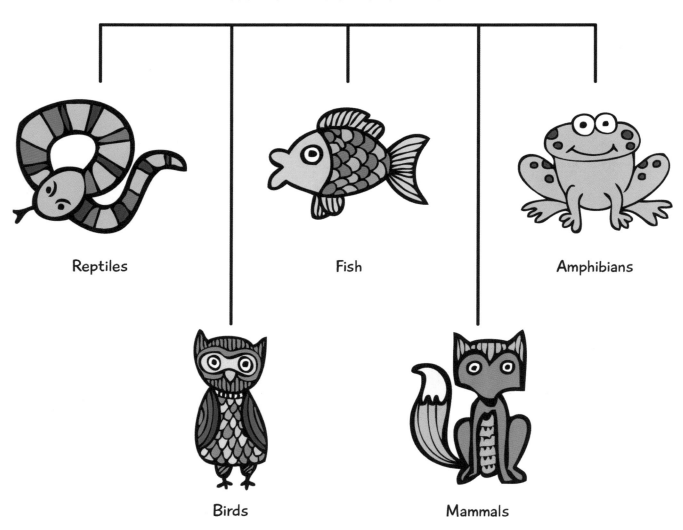

Reptiles

Fish

Amphibians

Birds

Mammals

Invertebrates

These are animals without a backbone.

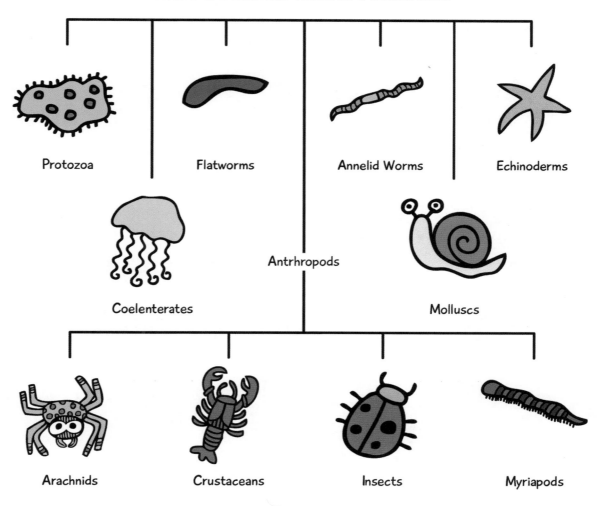

Protozoa

Flatworms

Annelid Worms

Echinoderms

Coelenterates

Antrhropods

Molluscs

Arachnids

Crustaceans

Insects

Myriapods

Science Fair

A science fair is great place to showcase your talent.

Solar System

Can you draw a picture of the planets in our solar system?

Food Chain

The food chain comes to life when we illustrate the sequence of events.

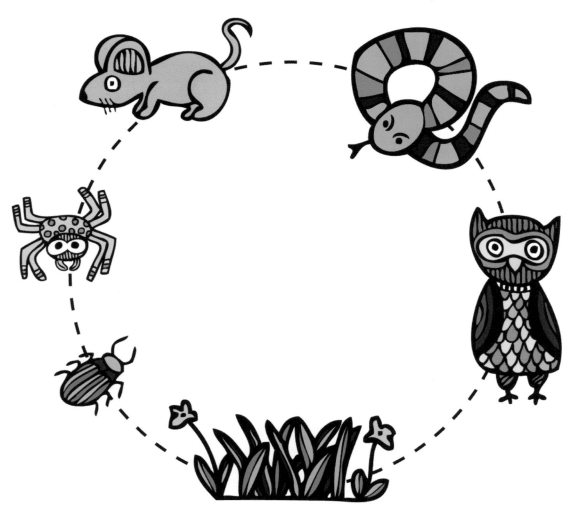

Maps & Models

Treasure Map

Drawing a map is a fun way to show the route to your secret treasure.

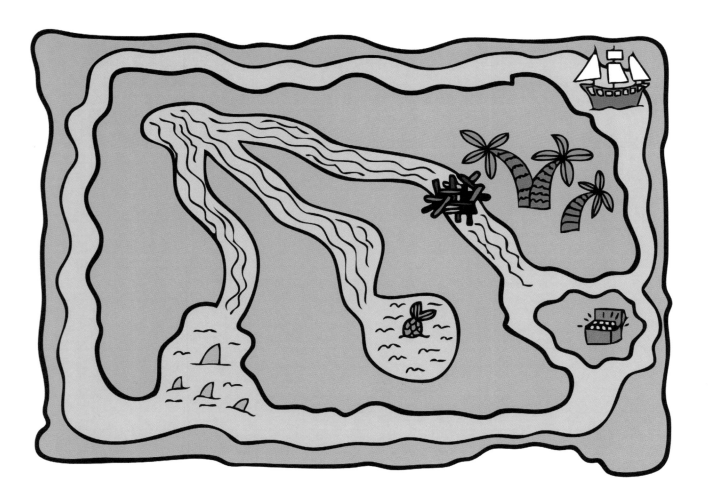

Farm Metaphor

The farm can represent your prized crop and what is necessary for a successful harvest.

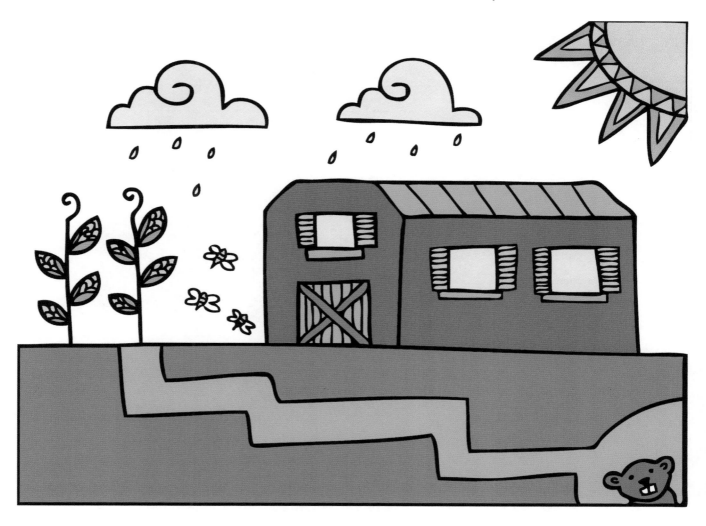

Four Square

A four square model clusters information and showcases the different relationships.

Pie Chart

Each slice of a pie chart can be used to show different values of data.

Ladder

What steps do you need to take in order to be successful at school or work?

Layers

Layers are used to show how information builds on each other.

Mapping Data

Maps start with a central topic and more information is added with branches.

Mapping Data

How creative can you be with the data you are mapping?

Maslow's Pyramid

Abraham Maslow invented a way to show the structure of needs with a pyramid.

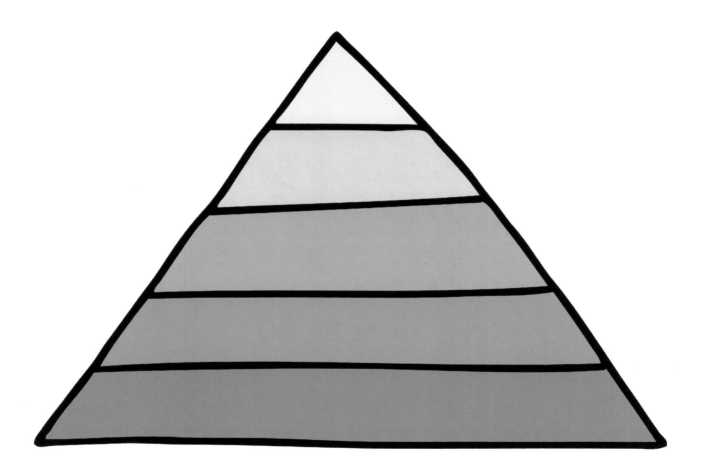

Pillars

Successful organizations are built upon a strong foundation and pillars of strength.

Spirals

Spirals showcase a swirl of complex information.

Target

A target is a powerful way to show the highest and lowest priorities.

Toolkit

Create a toolkit to describe your company's products and services.

Swiss Army Tools

What tools do you need in your toolkit?

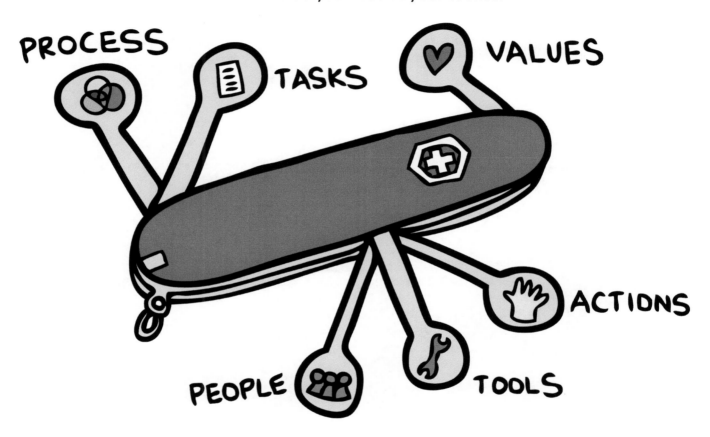

Building Blocks

Building blocks show the relationships between information.

More Building Blocks

Can you take the same information and represent it in different ways?

Communication Loop

Draw the communication loop to understand the flow of handoffs and dialogue.

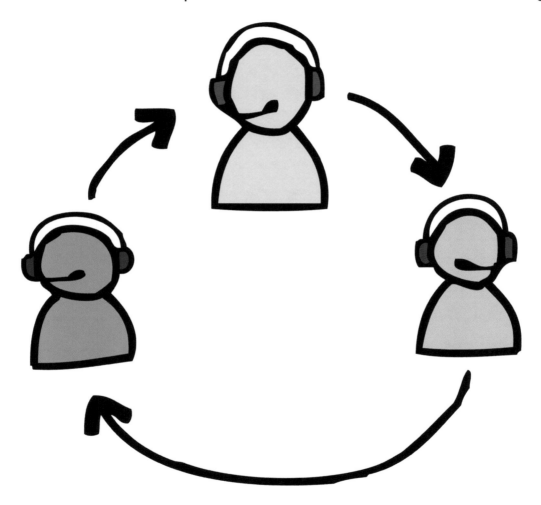

Iceberg

You've heard the expression "tip of the iceberg".
But what are the layers you can't see under the water?

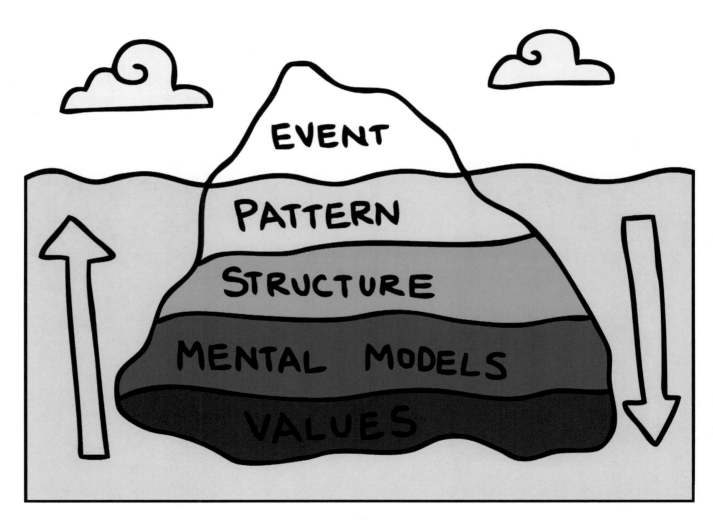

Venn Diagram

This diagram shows the relationship and overlap between ideas, topics and insights.

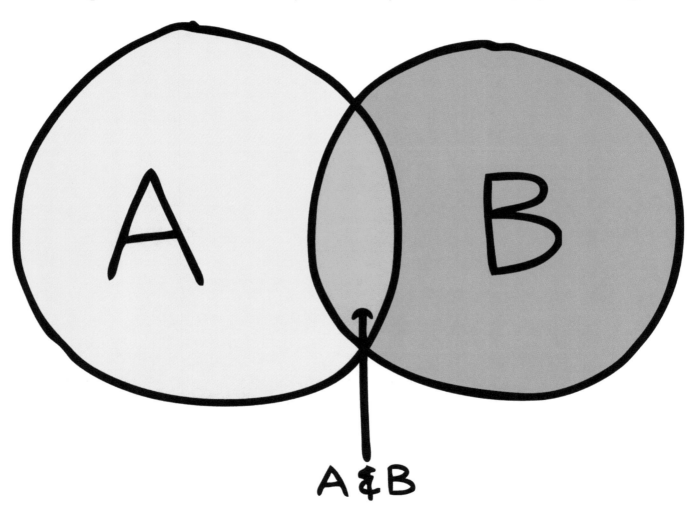

S.W.O.T. Analysis

A S.W.O.T. Analysis is a framework to evaluate products, places and industries.

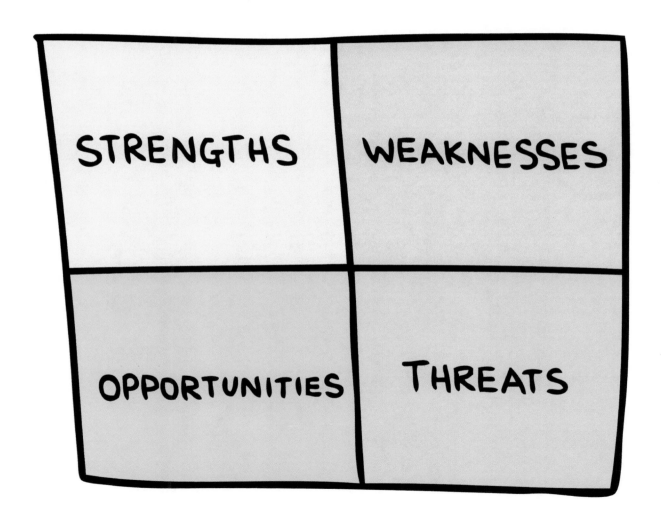

Puzzle

Can you show how pieces of information contribute to the whole?

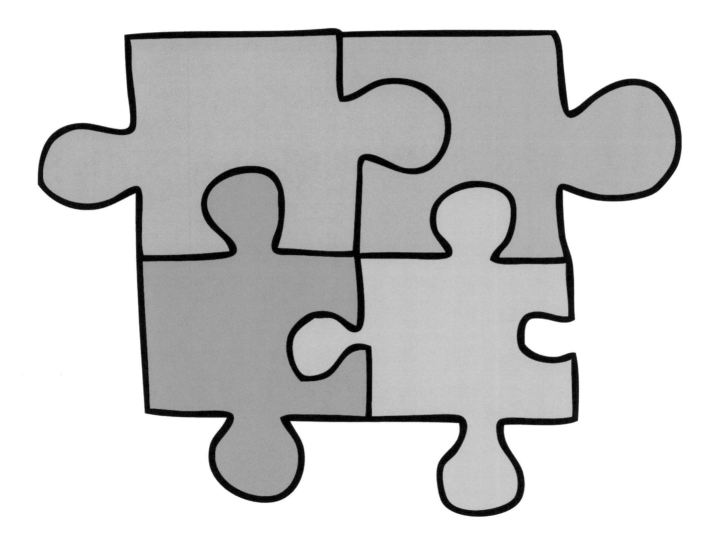

Business & Technology

Rules of the Road

Often we talk about the rules of the road, why not draw them?

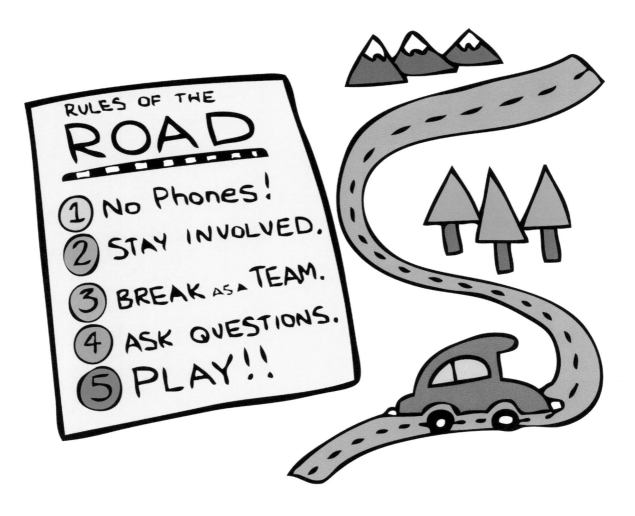

Agenda

A visual agenda is a great guide for both the meeting planners and participants.

TITLE	DAY 01	DAY 02	GROUP
OPENING	WELCOME	KEYNOTE	👤👤👤👤👤
ROUND ONE	WORKSHOPS Ⓐ Ⓑ Ⓒ Ⓓ Ⓔ	WORKSHOPS Ⓕ Ⓖ Ⓗ Ⓘ Ⓙ	
LUNCH	LUNCH	LUNCH	
ROUND TWO	WORKSHOPS Ⓐ Ⓑ Ⓒ Ⓓ Ⓔ	WORKSHOPS Ⓕ Ⓖ Ⓗ Ⓘ Ⓙ	
	REPORT OUT	REPORT OUT	FREE !
CLOSING	CLOSING	CLOSING	

Game Board

Game boards help you learn something new by playing with new ideas.

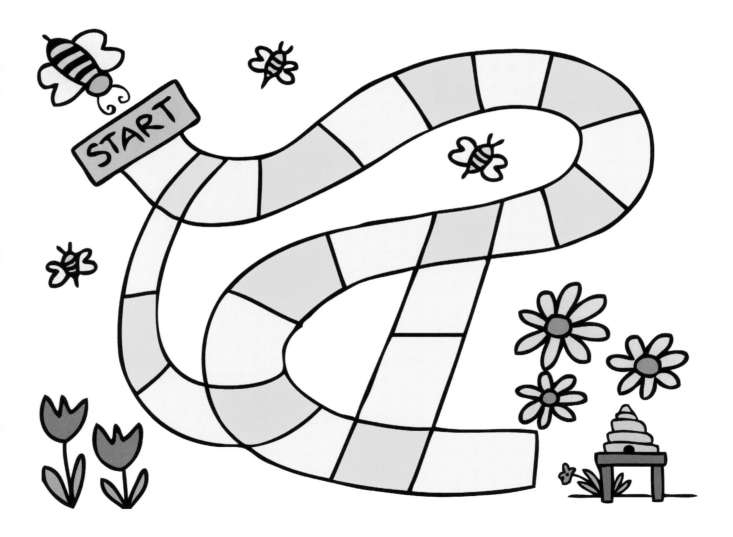

Event Setup

Have you ever made a sketch to show the room layout for an upcoming event?

Buzz Words

Business people love to use the latest and greatest buzz words.

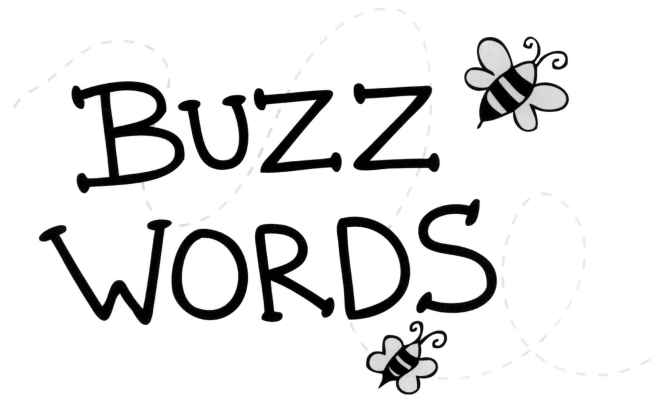

Visual Vocabulary

Can you create a visual vocabulary of the words you hear most often in meetings?

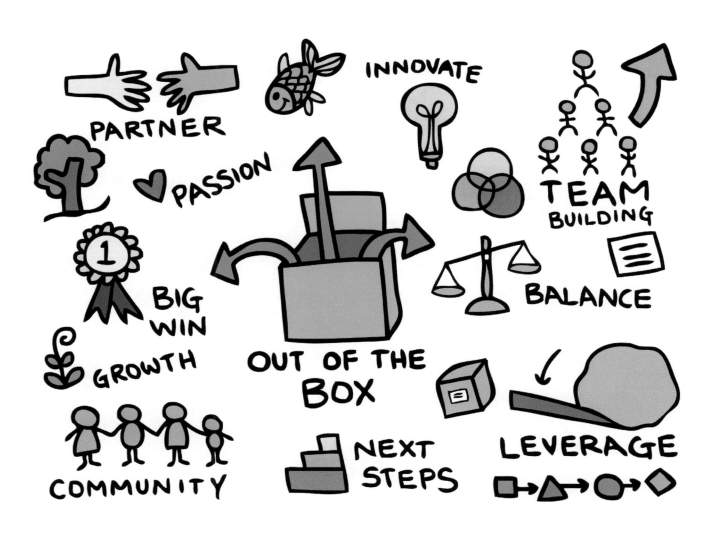

Sitemap

A sitemap helps users understand all the pages in a website.

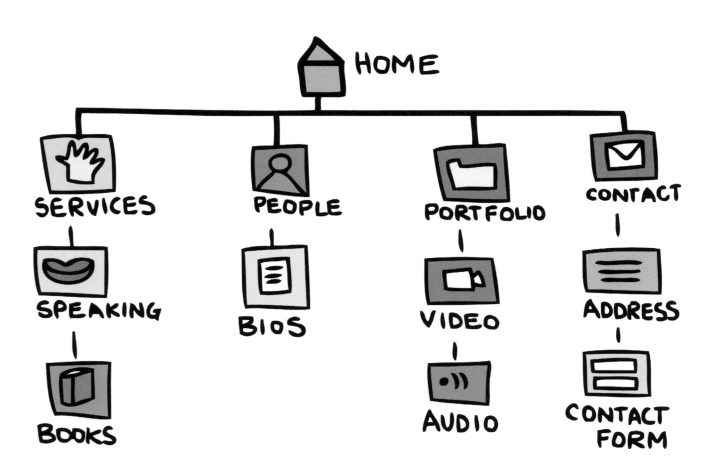

Organization Chart

Can you draw a picture of who people report to in your organization?

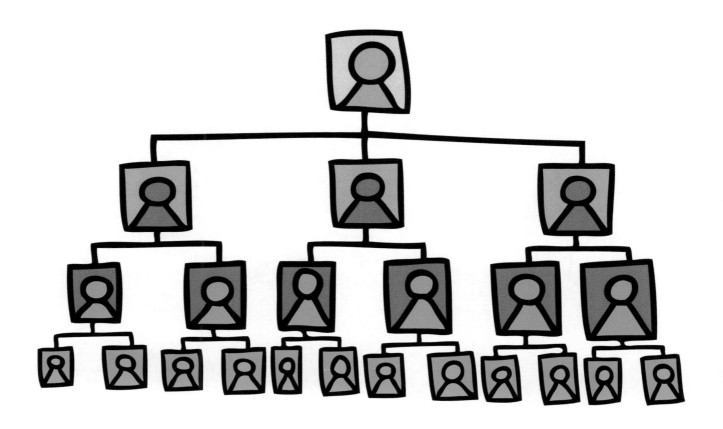

Product Ideation

It is fun to brainstorm new product ideas. Why not add a little sketch for each idea?

Product Ideation

Once you have a sketch you can drill down more into the possibilities of each idea.

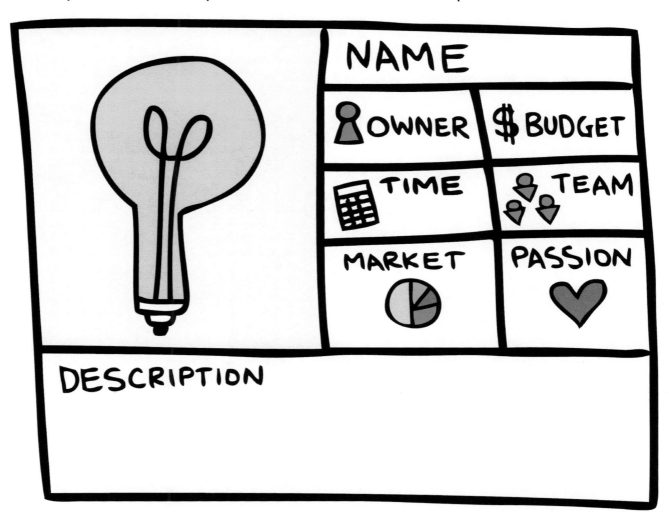

Target Ideas

Map out your new ideas on a target to determine where to start.

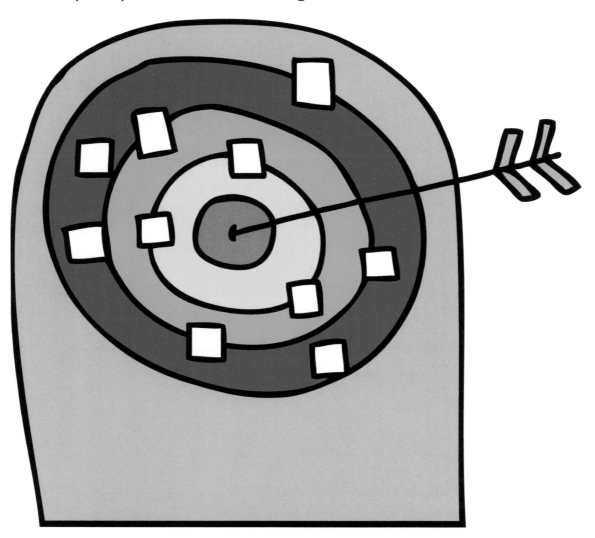

Growth

Can you organize your ideas on a growth chart to see which ones are best?

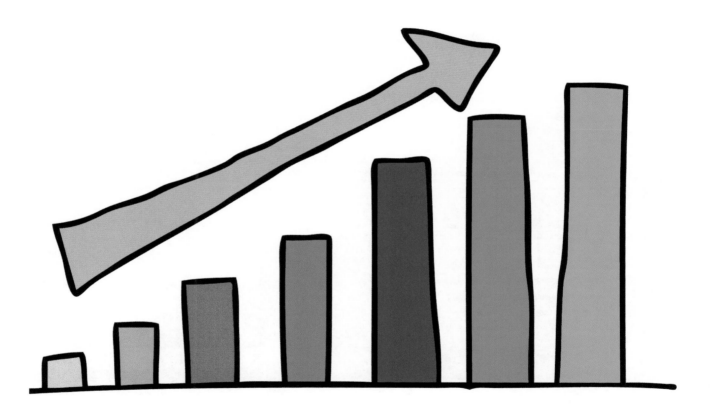

Wireframe for Application

If you were going to create your own application, what would it look like?

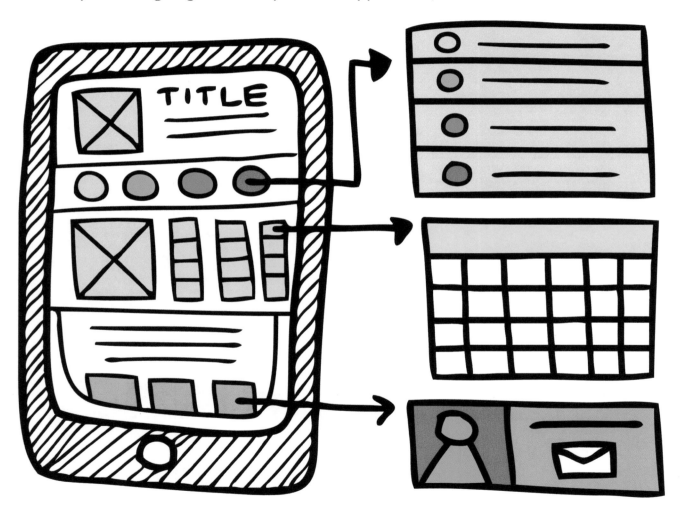

Wireframe for Websites

Or how would you lay out your website?

Workflow

Workflows are a great way to ensure that handoffs are seamless in your business.

Workflow

Here's another way to draw a workflow.

Tools & Processes

Trying to forecast for the next year? Make a chart to see what needs to be done.

Road Map

Try a road map if you have a complex process that needs to be simplified.

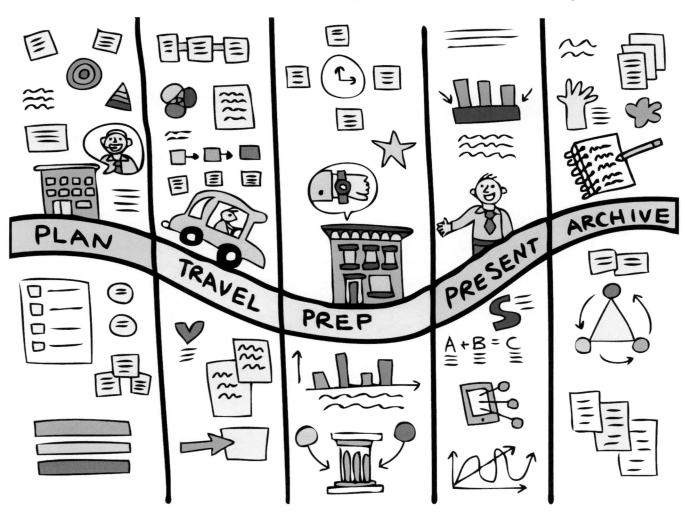

Inventory

Make a simple sketch to determine how to display your store products.

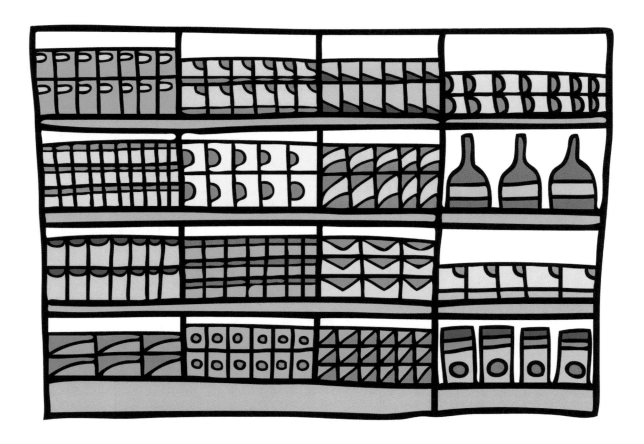

Customer Segments

Who are your customers and how do you serve them?

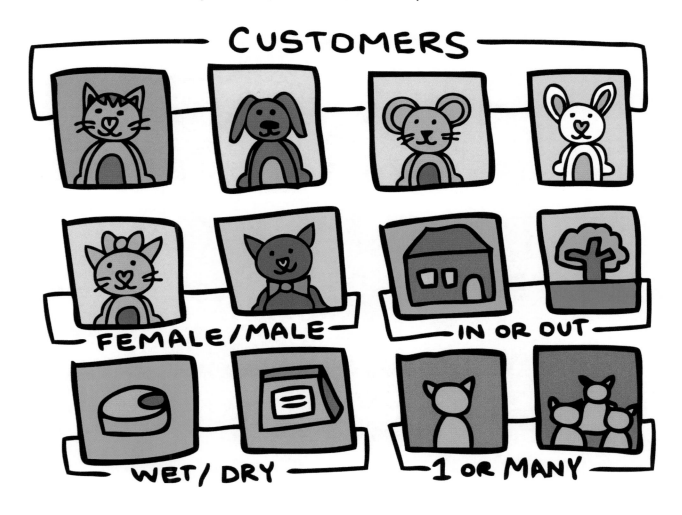

Dashboard

Dashboards help you get a pulse on complex data for team huddles.

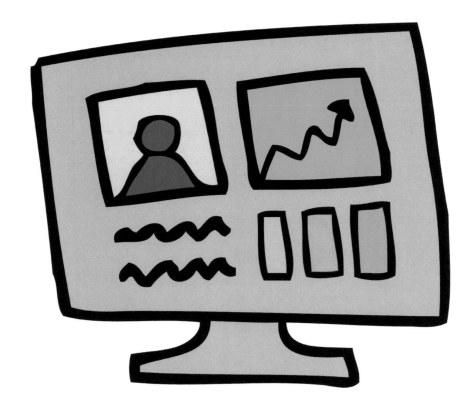

Business Planning

What are some of the business actions required every quarter?

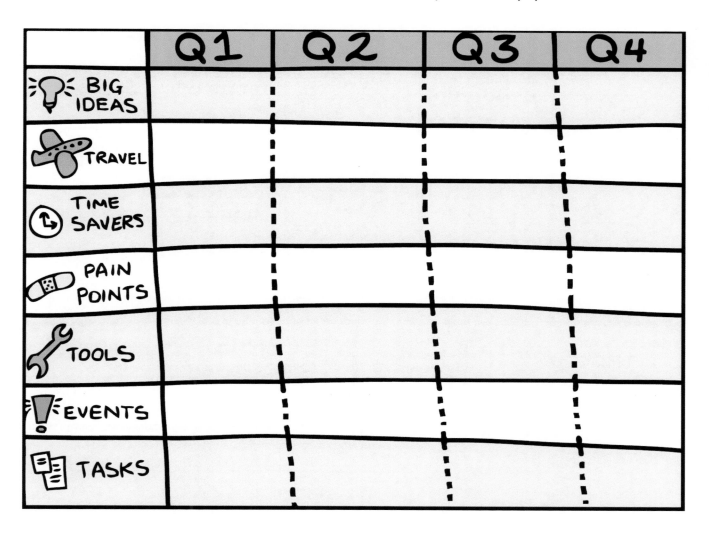

	Q1	Q2	Q3	Q4
BIG IDEAS				
TRAVEL				
TIME SAVERS				
PAIN POINTS				
TOOLS				
EVENTS				
TASKS				

Business Model

Business Model Generation created a powerful tool for understanding your business.

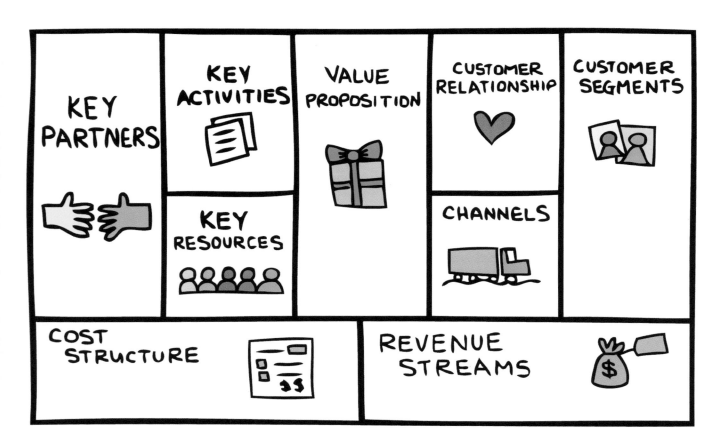

Hopes & Dreams

Dream Travel

Make a drawing of places you want to travel.

Dream Travel

Really try to image what it would feel like to be there.

Past, Present & Future

Look for the patterns in your life by doodling your past, present and future.

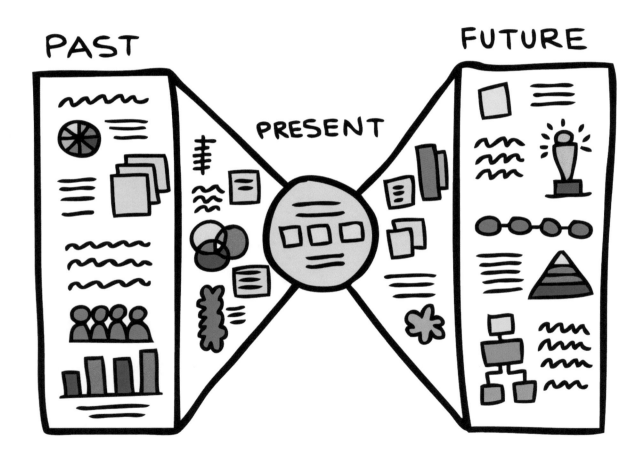

Pyramid of Hope

A pyramid of hope is a wonderful way to visualize your values, intentions and actions.

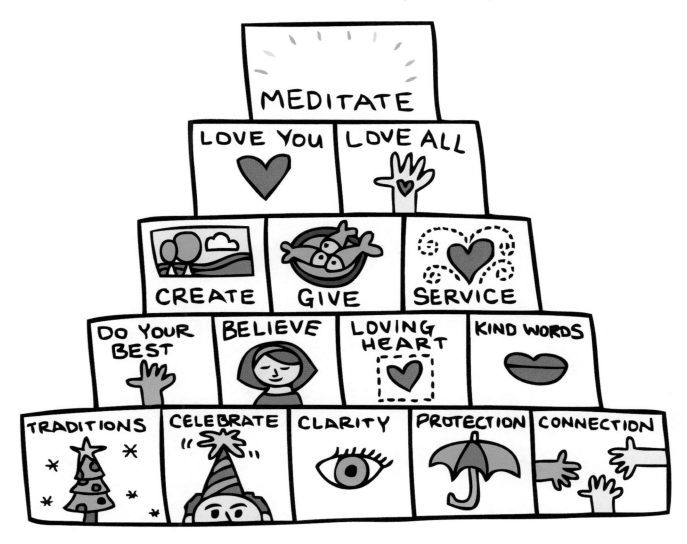

Dream Home - Exterior

What does your dream home look like? Is it in the city or the country?

Dream Home - Interior

Create a visual of how you would decorate your new home.

Mandala

Can you make a Mandala that represents you and your interests or values?

Mandala

Is there another way you can draw a Mandala?

Journey Map

A Journey Map is linear way to map your life events.

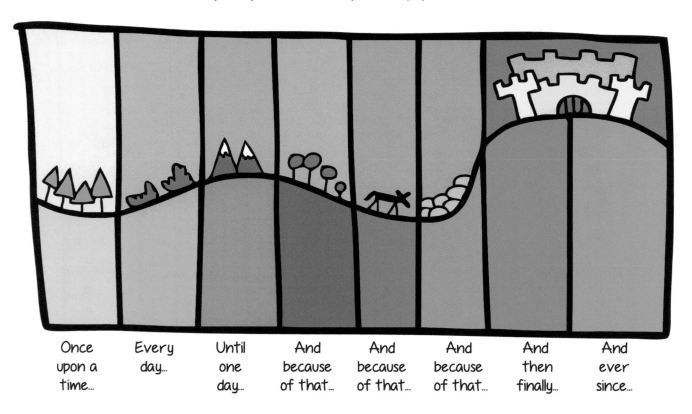

| Once upon a time... | Every day... | Until one day... | And because of that... | And because of that... | And because of that... | And then finally... | And ever since... |

Cinderella's Circle

Combine a mandala and journey map to represent your key actions and choices.

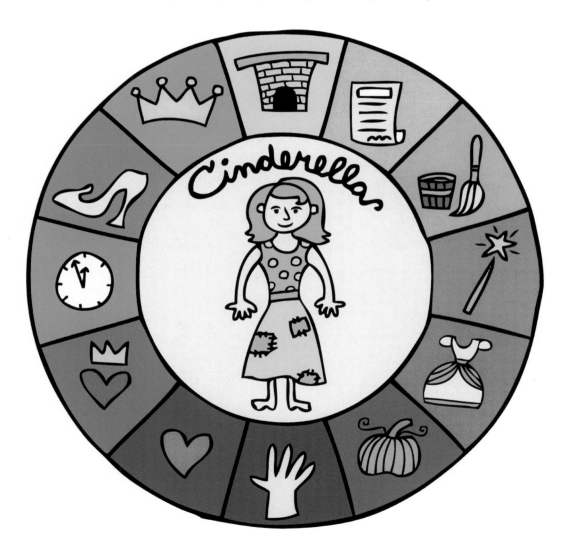

Cupcake Shop

Maybe you dream of starting your own business. Draw out your business idea.

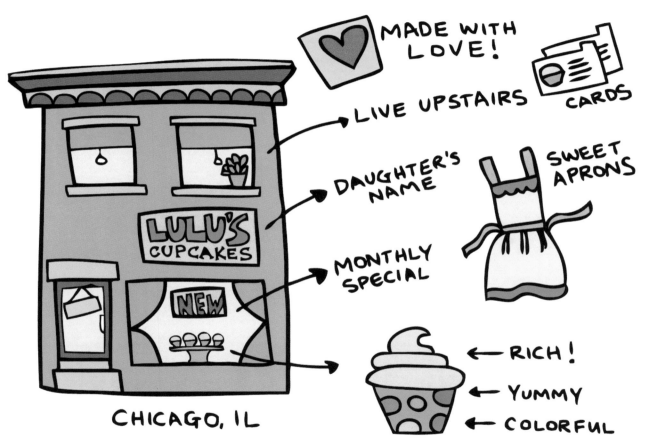

Taco Truck

Make sure you think of all the details. Have fun dreaming of the logo or menu.

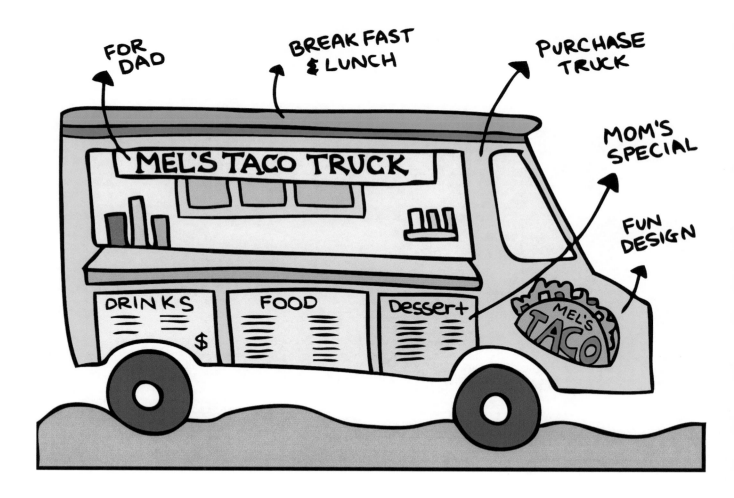

Vision Map

A vision map lets you play with "blue sky" thinking. What is your biggest dream?

Crystal Ball

Want to know your future? Pretend you are a fortune teller and draw the future.

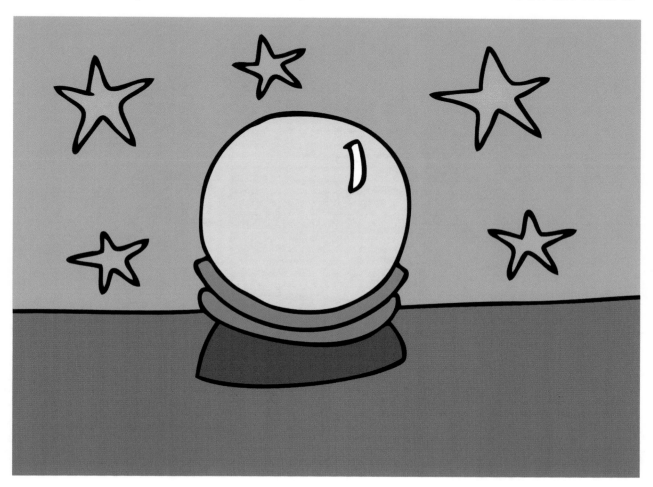

Movie

If your life was a movie, what is the title and who are the characters?

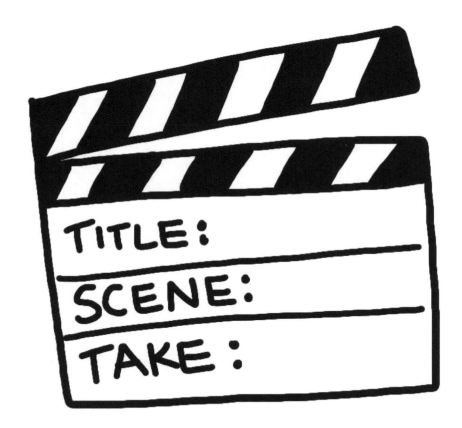

Fabric Design

If you could draw a pattern for your life, what would it look like?

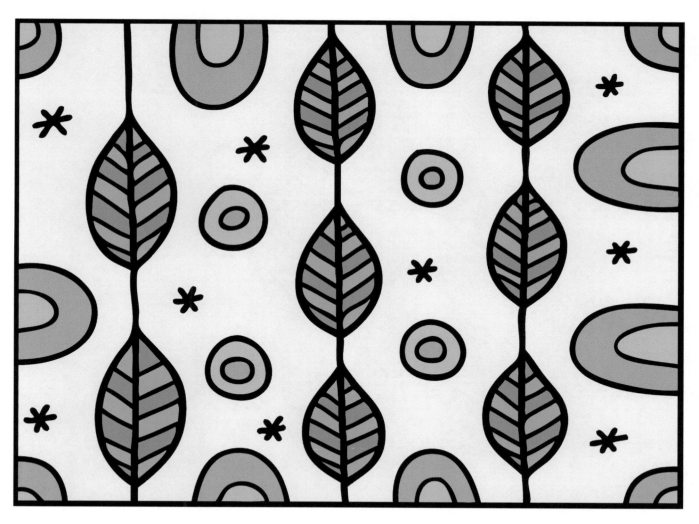

Your Inner Self

What does your inner self look like?

HOLD THE SPACE

FLEXIBILITY

LOVE

HAPPY HEART

SWIM IN CREATIVITY

Health & Healing

Balanced Diet

A healthy lifestyle begins with a balanced diet. What is special about your diet?

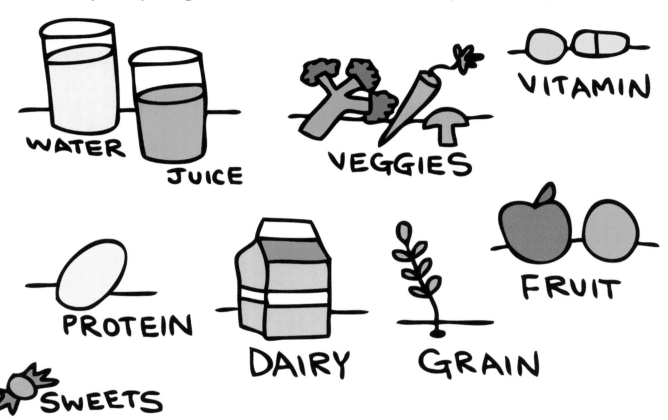

Grocery List

Sometimes a fun list makes it easy to make more healthy choices.

FRUIT	VEGGIE	BREAD	DIARY

FISH	BEAUTY	HOUSEHOLD	OTHER

Healthy Habits

Make a visual of healthy habits you wish to practice to keep you motivated.

		M	T	W	Th	F
	DAIRY					
	VEGGIES					
	PROTEIN					
	GRAIN					
	SWEETS					
	WATER					

Yoga Routine

Draw out your favorite workout routine so you can take it with you when you travel.

Down Dog

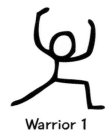

Warrior 1

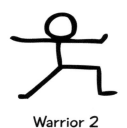

Warrior 2

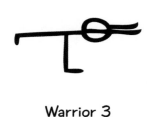

Warrior 3

Child's Pose

Mountain

Triangle

Tree

Head Stand

Infant Care

What are all the things a baby needs?

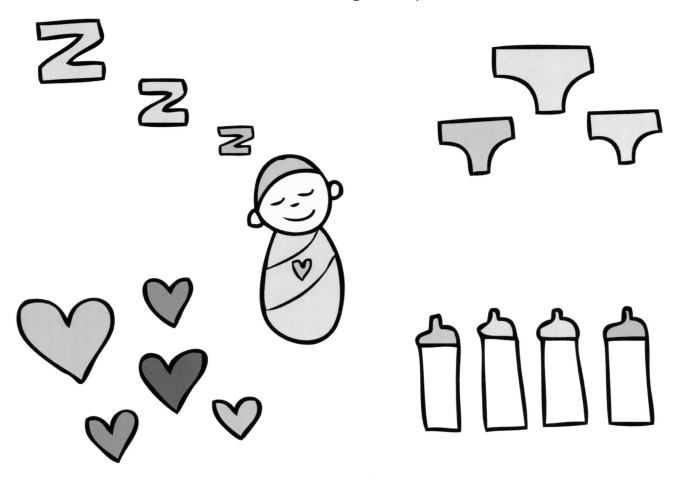

Baby Schedule

This is a fun way to track every hour of when a new baby eats and sleeps.

⏰	🍼🍼🍼	🩲 🩲	😊	😴
8:00				
10:00				
12:00				
2:00				
4:00				
6:00				
8:00				
10:00				

Life Milestones

Create a drawing of how you have grown to celebrate your life milestones.

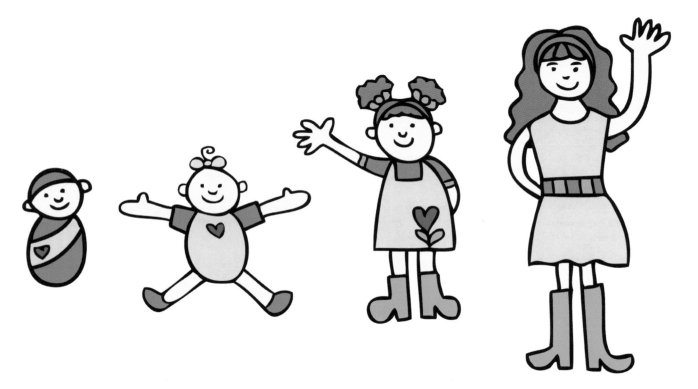

Balanced Life

What areas of your life are most important? And what areas do you give the most time?

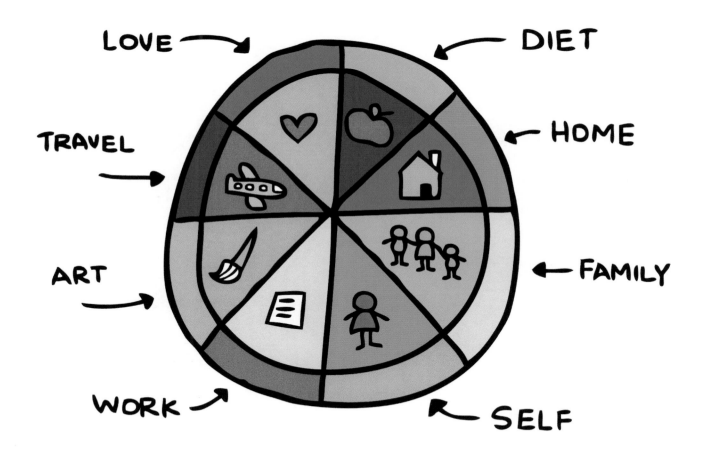

Self Care Poster

When your heart is full you can give to others. Create a drawing of the things you do to take good care of yourself.

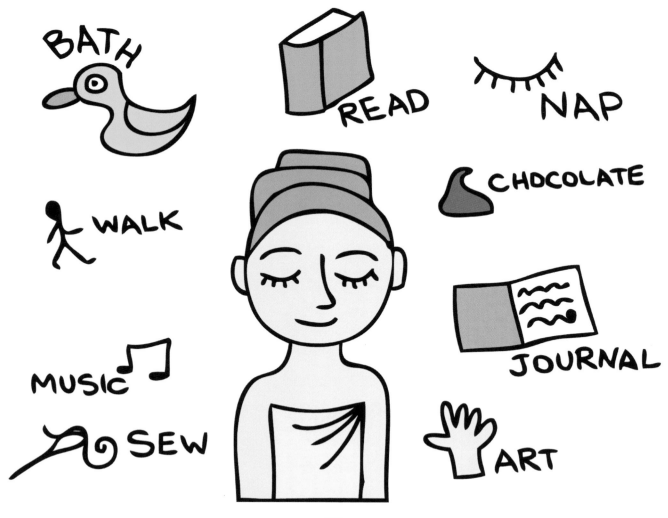

Healing Process

When facing a major life event, it helps to create a visual of the healing process.

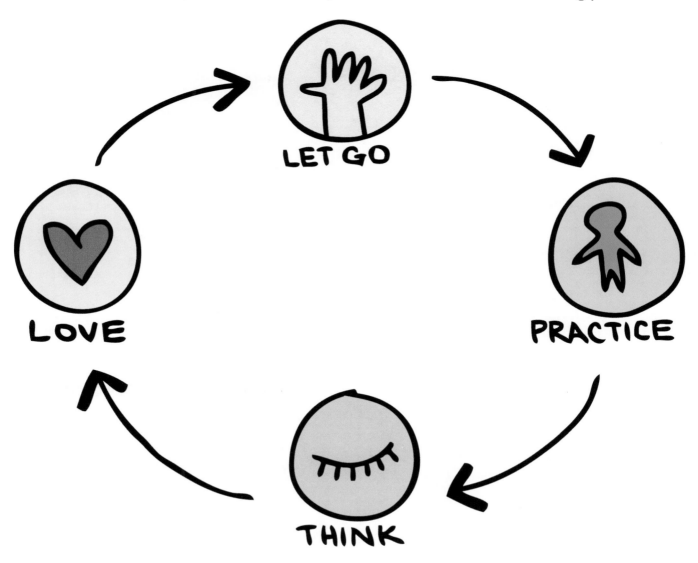

Divorce

As a family, you can create a drawing to represent the changes in your life.

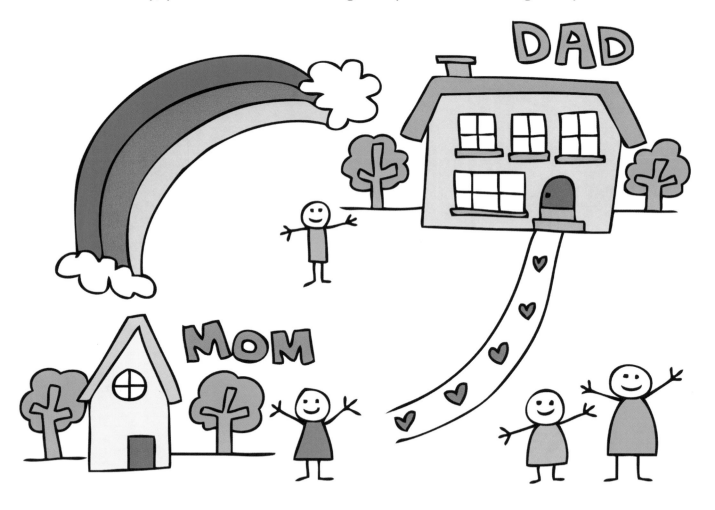

Story Quilt

You can draw on fabric to make a fun story quilt to celebrate a baby, a new marriage or to remember a special someone.

Medical History

Find a creative way to maintain your medical history.

Hospitals

Medical Records

Prescriptions

Notes

Doctors

Nurses

Pharmacists

Therapists

Medical Icons

Here are some simple medical icons you can use to share your patient story.

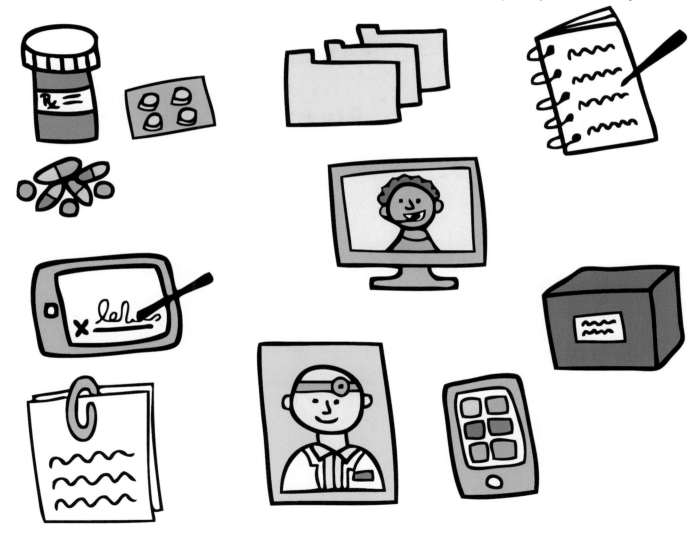

Medication Process

A visual reminder of the process for ordering your medication.

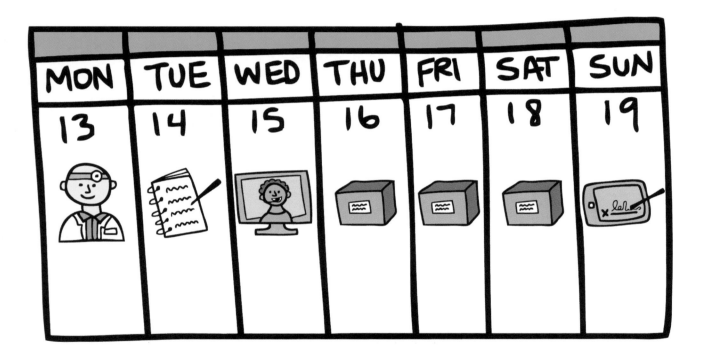

White Board Magic

Every hospital room has one. Why not use it for healing messages?

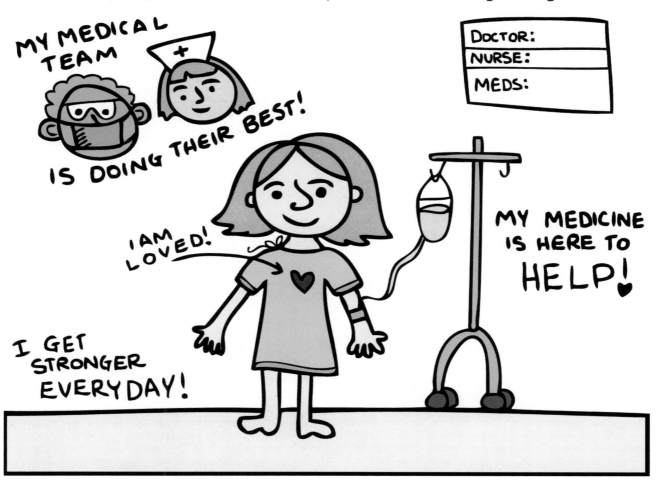

Visual Healing

Create a visual for all the healing energy of your surgery.

Visual Healing

What are the things you tell yourself as you are healing in the hospital?

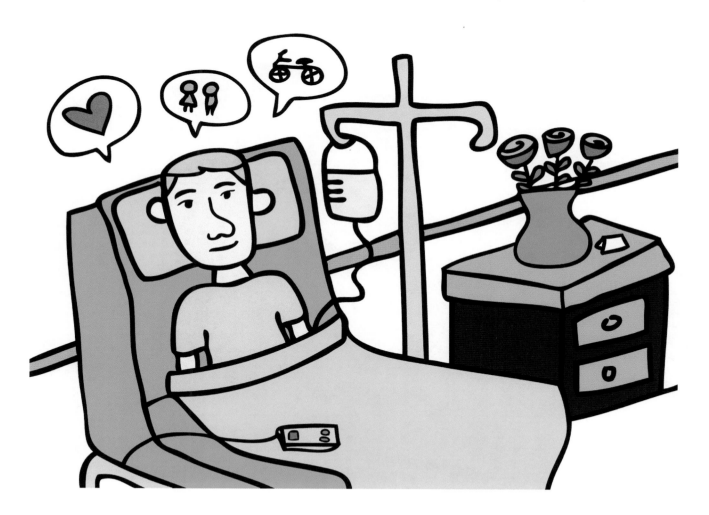

Love Letters

Write a love letter for someone you care about and fill it with doodles.

Sending Love

Another way to show you care is to create a big poster and mail it to a friend.

Meditation

Visualize something that calms and centers you for your day.

Prayer Flags

What are your prayers for how you wish to live your life?

Zentangle

Learn the art of Zentangle which will help you practice staying in the now.

Bonus Material

Clouds

Speech Bubbles

More Borders

More Borders

Titles

Titles

STREET SIGN · LANDSCAPE · Swirly · tabs · CLOUD · HAPPY! · IDEA · LEAVES

Icons

Icons

Icons

Icons

Circles

Squares

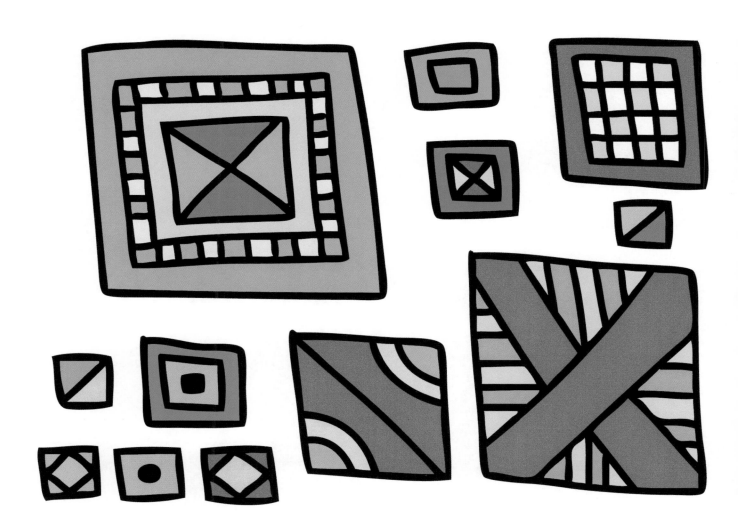

Triangles

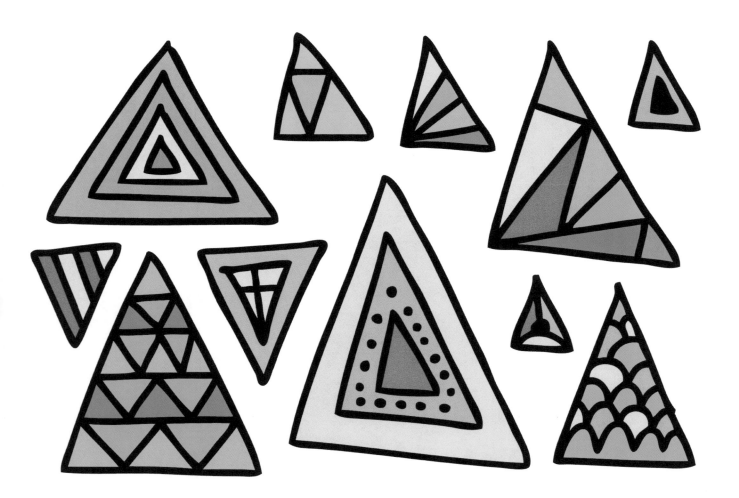

Just Doodle

Tools

Find the tools that work best for you, your audience and your style.
Remember, it is okay to get messy when you doodle.

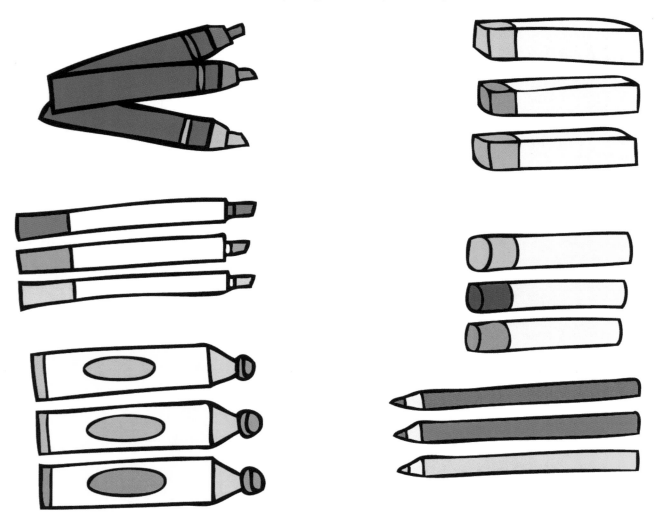

Surfaces

Here are some suggested surfaces. But really you can draw on just about anything.

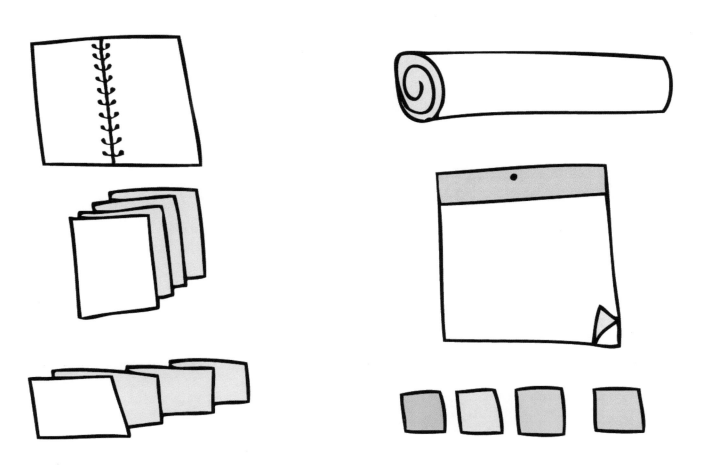

You're Ready!

Now you can begin to create a Doodle Sketchbook
of your very own.

We would LOVE to see what you create.

Please send us a copy to: art@discoverydoodles.com

Meet Alicia Diane Durand

I believe in living my life fully immersed in creativity every day, as well as being a Creator of Change in the world. As a young child, I loved to color and draw. My family and friends would always comment on my pictures, because they were different. I've been connected to drawing since I was a kid and have continued to doodle throughout college and into my career and parenting.

I absolutely love to dream, discover and doodle with my two daughters Lillian and Lucy.

Discovery Doodles

Drawing **your** ideas around the world.

Sketchbook Basics
Alicia Diane Durand

Early Childhood
Alicia Diane Durand

Around the World
Alicia Diane Durand

Math & Science
Alicia Diane Durand

Maps & Models
Alicia Diane Durand

Business & Technology
Alicia Diane Durand

Hopes & Dreams
Alicia Diane Durand

Health & Healing
Alicia Diane Durand

BUSINESS · EDUCATION · FAMILIES

Check out our online videos & courses @ www.DiscoveryDoodles.com

MARKERS MAKE MEANING

WE MAKE THE MARKERS

neuland®
www.neuland.com

Made in the USA
Lexington, KY
12 October 2013